THE
COMPLETE
IDIOT'S
GUIDE® TO

Graphic
Design

*by Marjorie Crum and
Marcia Layton Turner*

ALPHA

A member of Penguin Group (USA) Inc.

ALPHA BOOKS

Published by the Penguin Group

Penguin Group (USA) Inc., 375 Hudson Street, New York, New York 10014, U.S.A.

Penguin Group (Canada), 10 Alcorn Avenue, Toronto, Ontario, Canada M4V 3B2 (a division of Pearson Penguin Canada Inc.)

Penguin Books Ltd, 80 Strand, London WC2R 0RL, England

Penguin Ireland, 25 St Stephen's Green, Dublin 2, Ireland (a division of Penguin Books Ltd)

Penguin Group (Australia), 250 Camberwell Road, Camberwell, Victoria 3124, Australia (a division of Pearson Australia Group Pty Ltd)

Penguin Books India Pvt Ltd, 11 Community Centre, Panchsheel Park, New Delhi—110 017, India

Penguin Group (NZ), cnr Airborne and Rosedale Roads, Albany, Auckland 1310, New Zealand (a division of Pearson New Zealand Ltd)

Penguin Books (South Africa) (Pty) Ltd, 24 Sturdee Avenue, Rosebank, Johannesburg 2196, South Africa

Penguin Books Ltd, Registered Offices: 80 Strand, London WC2R 0RL, England

International Standard Book Number: 978-1-59257-806-1
Library of Congress Catalog Card Number: 2008924720

10 09 08 8 7 6 5 4 3 2 1

Interpretation of the printing code: The rightmost number of the first series of numbers is the year of the book's printing; the rightmost number of the second series of numbers is the number of the book's printing. For example, a printing code of 08-1 shows that the first printing occurred in 2008.

Printed in the United States of America

Note: This publication contains the opinions and ideas of its authors. It is intended to provide helpful and informative material on the subject matter covered. It is sold with the understanding that the authors and publisher are not engaged in rendering professional services in the book. If the reader requires personal assistance or advice, a competent professional should be consulted.

The authors and publisher specifically disclaim any responsibility for any liability, loss, or risk, personal or otherwise, which is incurred as a consequence, directly or indirectly, of the use and application of any of the contents of this book.

Most Alpha books are available at special quantity discounts for bulk purchases for sales promotions, premiums, fund-raising, or educational use. Special books, or book excerpts, can also be created to fit specific needs.

For details, write: Special Markets, Alpha Books, 375 Hudson Street, New York, NY 10014.

Publisher:	Marie Butler-Knight	Copy Editor:	Jan Zoya
Editorial Director:	Mike Sanders	Senior Designer/ Technical Editor:	William Thomas
Senior Managing Editor:	Billy Fields		
Development Editor:	Ginny Bess Munroe	Indexer:	Joan Green
Production Editor:	Megan Douglass	Proofreader:	Mary Hunt

For my family, who supported me through this effort,
you are the center of my life. And to my husband, Frank,
I love you for supporting me and encouraging me to follow my passion.
—Marjorie L. Crum

Contents

Introduction

You now hold in your hands a crash course in the basics of graphic design—the critical principles and techniques you need in order to create eye-catching ads, brochures, flyers, and other promotional tools.

Whether you've been tasked with designing a simple newsletter for your organization, or producing a holiday card as part of your volunteer work in the community, you now have a handbook to guide you through the process. You'll get both the broad overview and the step-by-step details here, both aimed at getting you started quickly on your graphic design project, whatever it is.

How This Book Is Organized

This book is presented in six sections:

Part 1, "Getting Up-and-Running," is written to help you quickly get up to speed on basic graphic design facts and principles. Just like on the first day of school, you get the big picture regarding what you'll be learning, as well as hearing about what tools you'll use regularly, and where to find design inspiration. Because you can't design anything effectively without essentials like pencils and pens, a straightedge, and some paper, you'll be handed a laundry list of "must-have" and "nice-to-have" equipment. Then you'll get the lowdown on starting to map out your design ideas.

Part 2, "Incorporating Words," is all about type, or the letters and words in your design. Although we tend to think of images first in relation to design, the words that accompany or complement images are equally important. In addition to learning how to best choose a typeface that reflects the look and feel you are trying to evoke with your design, you'll also hear about visual hierarchy. At the center of effective design, the principle of visual hierarchy is that your eye will move from the most to the least important element in a design when laid out properly. In this section, you'll figure out how to do that.

Part 3, "From Black and White to Color," begins with an overview of the many colors available to you, and the emotions they can evoke when used within a design. On top of choosing the colors you'll use within your design, you'll also see how color placement can strengthen or weaken their impact, too. Finally, depending on where your design will be seen—online or in print—paper can play an important role. Adding another design dimension, the color, texture, and weight of the paper you choose can alter the overall appearance of your design. We will also cover how to make sure you select the correct color palette, based on your design output.

Part 4, "Adding Pictures," is all about choosing from the many different types of illustration and photographic techniques and subjects. When is a photo a better choice than an illustration? Where can you even find an illustrator? Are there guidelines for selecting a subject? You'll get the whole scoop here, along with some useful resources.

Part 5, "Grids and Templates," is all about taking the individual pieces of your design—the images, the text, and the graphic elements like a logo or decorative squiggle—and placing them systematically into the design. You'll learn how using a grid can make alignment a snap, and how templates can provide a short-cut, but not without downsides, such as a cookie cutter appearance. Then once you have your elements in place, you'll find out how to produce a comprehensive, or comp, that ties everything together.

Part 6, "Putting It All Together," takes you to the next step—examining specific kinds of designs and viewing innovative approaches other designers have taken. You'll see examples of well-designed advertisements, letterhead, envelopes, business cards, logos, brochures, newsletters, information kits, post cards, flyers, promotional goodies, and websites. By reviewing how design pros have created notable examples of many business and personal productivity tools, you can start to develop your own ideas for how to approach projects you have in mind.

Things to Help You Out Along the Way

You will notice that throughout the chapters, we've included some special messages along the way.

Definition

The first time we use a graphic design term you may not be familiar with, we'll define it here for you.

Creative License

We'll feature great design ideas or examples here, to be sure you don't miss them.

Reverse Type

Sometimes the right tool used incorrectly can produce a design that looks downright amateurish. To help you avoid looking unprofessional, we'll point out common stumbling blocks here.

Design on the Cheap

If there's a way to save a few bucks here and there on production, we'll point it out loud and clear in these sidebars.

Acknowledgments

Thanks are owed to many for their support in creating this book. First, to my co-author and friend Marcia Layton Turner, you constantly inspire and amaze me with your talent. For my friend, colleague, and office-mate Jim Downer, your illustrations always make me laugh, and I thank Diane for sharing you with me. For my friends, colleagues, and students, especially those in the design profession and AIGA, I am always inspired by your talent and magnanimous spirit—Life would be boring without your presence.

A number of graphic design pros helped in the production of this book, offering ideas and examples that really bring the subject-matter to life. These terrific, talented folks include Audrey Bennett, Kathleen Brien, Laura Coburn and her staff, Whitney Crum, Jim Downer, Jane Glazer, Justin and Carmen Kennedy, Terry Marks, Ashley Rio, Deb Rizzi, Beth Singer Design, Jason B. Smith, Marc Stress and his staff, Emily Tamasovich, Nate Tharp, Toky Brand + Design, Bernard Uy, James Wondrack, and Tony Zanni.

At Alpha Books, we thank Mike Sanders for his guidance and support, Ginny Bess Munroe for her expert editorial skills, and Megan Douglass, the production editor.

We also thank our agent, Bob Diforio, for his support and encouragement.

Trademarks

All terms mentioned in this book that are known to be or are suspected of being trademarks or service marks have been appropriately capitalized. Alpha Books and Penguin Group (USA) Inc. cannot attest to the accuracy of this information. Use of a term in this book should not be regarded as affecting the validity of any trademark or service mark.

PART 1

Getting Up-and-Running

This part is devoted to helping you understand what graphic design entails, and how best to approach a particular design assignment, given the time, money, and resources you have at your disposal. We cover design tools you'll want to have at-the-ready—everything from a computer to design software, to art supplies, to an ergonomic chair. We point you in the right direction to start sketching possible design layouts, armed with a primer on studying your audience, design elements, and design principles.

CHAPTER 1

Getting Started

Graphic design is an exciting process that turns raw marketing and promotion ideas into printed and electronic tools. From business cards, labels, or signage, to brochures, logos, or direct mail pieces, the principles of graphic design you learn here will help you create more eye-catching and more effective pieces. Just a few of the materials graphic designers produce include:

- Business cards
- Stationery and envelopes
- Invoices
- Brochures
- Website
- Internet banner advertisements
- Print advertisements
- Postcard mailers
- Flyer/pamphlets
- Posters
- Invitations
- Catalogs
- Annual reports
- Newsletter—print
- E-zine

Good graphic design makes information more understandable and more appealing. Using visual tricks of the trade, designers can quickly communicate a message, a feeling, or a style through their designs.

History of Graphic Design

Graphic design is the process of communicating through the use of text and image. This practice of visual communication includes the use of symbols, aesthetics, and craftsmanship. The term graphic design refers both to the process through which the communication is created, as well as that which is produced.

The earliest examples of graphic design can be found in images humans made in caves, up through the development of the alphabet. Tools used to record history evolved as the need for skilled craftsmen increased. The Industrial Revolution created a need to advertise goods mass-produced and the need for graphic designers grew again. From the mid-twentieth century to present day the need for visual communication has grown and graphic designers are increasingly called upon to give visual order to complex information.

Today graphic designers work in many areas of the world of corporate communication. Designers are responsible for creating and maintaining the visual identity for a company in everyplace a company logo or name appears. Graphic designers work with writers, photographers, programmers, and PR and marketing staffers to create advertisements, brochures, signage, websites, and other tools to promote a company. A solid foundation in fine art classes, including drawing, two-dimensional, and three-dimensional design, coupled with theories and practice makes a skilled craftsman a valuable asset to a company's marketing team.

Graphic designers who work for corporations are usually referred to as "in house" designers, while those who work for themselves are often referred to as "freelance" designers. Someone with an associate's degree wanting to work as a graphic designer could expect to start as a production artist, while someone with a bachelor's degree would start one step higher, as a junior graphic designer. The typical career path for a graphic designer is production artist (usually associate's degree only), junior graphic designer, senior graphic designer, art director, and creative director. The design-focused companies often have other, more specialized position titles dependent on the focus of the company. Some examples might be brand identity developer, logo designer,

illustrator, visual image developer, content developer, and multi-media developer. There might be overlap in the responsibilities of these positions but generally they fall within the senior graphic designer's and art director's duties.

So how do you even approach a design project? Let's get started.

What Do You Need?

If you're beginning your first graphic design assignment or your hundredth, the first things to evaluate before you get started are when your design needs to be completed and what tools and resources are available to help you. Those limitations are then coupled with background information about the purpose of the design, the target audience, message, and overall look and feel.

How Much Time Do You Have?

Most projects have a well-defined endpoint. That is, you probably have a date by which you need your project to be done. If you're designing an invitation, you need everything to be designed and printed about a month before the event. If you're creating a new corporate capabilities brochure, you may want to have it done before your busy work season. Or if you need a website because customers are complaining they can't order online, your deadline to get it up and running may be "as soon as humanly possible."

Whenever you begin a new design project, create a job jacket or folder to hold all the information you need to get the job done. Write key contact names, such as photographers, copywriters, or printers, on the outside of the folder or on a sheet within. File away pictures of stock images you may want to use, or examples of similarly designed pieces you like for inspiration and for easy retrieval later.

If your window of opportunity to complete your project is small, such as a matter of days, you'll want to start brainstorming what can be done given those restrictions. Can you draft a flyer on your computer and print it out in the office? Or can you pay rush charges to get some new business cards produced through an online service like Vistaprint.com?

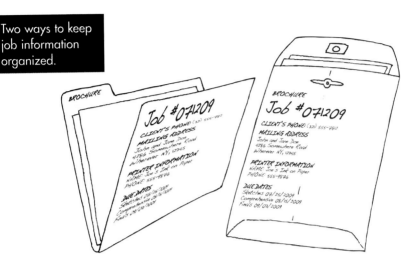

Two ways to keep job information organized.

Start by determining your completion date, and work backward using a calendar to set internal deadlines to get everything done on time.

For instance, if you need your printed piece in a week, you know you probably can't have a commercial printer involved because they typically need at least a week to do their job. But maybe a quick printer can turn it around in a couple of days. So now you have five days left to get the piece written and designed on your computer and handed off to the printer. And with five days to work, you probably aren't going to have time to bring in a photographer to take any on-site photos, so you'll need to use those stock photos you've filed away. It might be tight, but you can get it done.

Conversely, if you have months until your boss expects to see an overhauled website, you have time to interview several web gurus and hosting companies, and consider having new photos taken. You'll still want to work out a schedule and set milestones to stay on track, but you have far more options to work with on the more realistic schedule.

A **PDF** file, short for portable document format, is a means of saving files and sharing them electronically. PDF files look like a printed document, but are printed by the recipient with their own equipment.

Printed or Electronic

As you begin, you should also consider whether you need to design a printed piece or whether it can be distributed electronically. Preparing a file for print production takes time, and the printing itself takes money, so if you're short on either, take a close look at your electronic options.

Can you create an e-mail announcement versus a direct mailer? Or how about a four-color brochure, saved as a *PDF* file rather than on paper?

Who Is Your Audience?

Once you've determined how much time you have to design something, and what kinds of resources are available to assist you, you also want to evaluate the audience you're targeting. Who are you trying to reach, and what are you trying to achieve?

Here are some examples of potential audiences:

- Employees
- Customers
- Volunteers
- Community members
- An awards committee
- Business clients

Who you're addressing will affect the type and style of piece you design and how much time you'll need as well.

You also need to decide what you want your piece to accomplish. For example, are you attempting to ...

- Generate new business?
- Reconnect with old customers?
- Garner support for a legislative issue?
- Raise money for a charity?
- Invite participants to a charity auction?
- Increase awareness of a new service you've introduced?

There are many reasons to design something, and you need to zero in on your one key message. Knowing your purpose will help define what your design should contain.

Finding Examples

Staring at a blank page in the hopes of suddenly conceiving a creative design idea can be daunting, not to mention time-consuming. So instead of starting with nothing, start by looking at what others have come up with that you like.

Scoping Out the Competition

Taking a look at what your local competitors use in the way of marketing materials is smart, both so you know how they are positioning the business and so you know what you can do to make your company stand out against them. Collecting competitor materials is a form of competitive intelligence, or information-gathering.

In addition to looking at your competitors' designs, there are a number of sources you can turn to immediately for inspiration:

- Conduct an online search for businesses like yours outside your area, and request their marketing materials.
- Look at what arrives in your mailbox with a critical eye.
- Study the looks and approaches used in other industries.
- Review the online portfolios of other designers.

Creative License

Ask almost any professional graphic designer about the best source of ideas and you'll likely hear about their "swipe file." A swipe file is a folder into which designers place examples of good work they've come across. Although they would never steal an exact design, examples suggest other ways to approach future design projects.

Your Personal Preferences

Just as important as knowing what the competition is up to is figuring out what appeals to you. What styles do you prefer? What new and different approaches have you seen that might work for your project?

To gather ideas, tap into these resources:

- Pick up literature at networking meetings and conferences.
- Skim books that showcase some of the best designs of the year.
- Look at what other companies targeting your market use in the way of design.

Try to take your customers' perspective when designing anything, whether it's a new product or an informational newsletter. Then take a look at what your competition is doing and decide if you want to look like them, or look very different.

Many designers keep samples for reference.

Determining the Budget

While the design possibilities for any project are wide open, it's unlikely your boss or your budget is as open-minded. As with everything else, you'll want to see how much you have to spend before you get started in creating an invitation, flyer, or website for your company. The amount you have to spend can quickly shape your design options. However, throwing more money at a project won't necessarily make it any better.

No matter what your budget, you'll be able to produce some form of design as long as you have access to a computer, printer, and paper. However, the more money you have set aside to pay for creation of your piece, the more flexibility you'll have in designing and printing it.

How Should You Spend It?

A budget sets parameters for you to work within. The number of pieces you can design and print for $1,000, for example, is far less than if you had $10,000 or $50,000. So you may opt to spread your money around a handful of projects, rather than trying to tackle a laundry list.

Setting priorities is always a smart move at this point, and can help you decide how best to allocate the money you have.

Once you create a prioritized list of the items you need to design, you're in a better position to begin work on those you need most, based on how much money you have to spend.

Do You Need an Outside Vendor?

Unless your budget is $0, you'll almost always need outside vendors.

These service providers support you in your efforts to produce well-designed pieces. They include:

- Photographers
- Illustrators
- Writers
- Printers
- Mailing houses
- Stock image houses
- Paper company representatives
- Graphic designers

You may be wondering why we included graphic designers on your list of service providers when you may be reading this book to learn how to avoid hiring them. Well, the truth is, you may encounter a project where you don't have time or the capabilities to do what is required, or you simply don't feel comfortable tackling a major initiative without some backup. Professional graphic designers call on their colleagues for backup all the time, and you shouldn't feel guilty for doing so, either.

The Ideation Process

Ideation, or coming up with ideas, is usually easiest when done by hand, using paper and pencil. Although the computer has become an important part of the design process, at the start, doodling and conveying ideas to paper by hand works best.

Brainstorming Techniques

Using paper and pencil, start by sketching out symbols, such as if you're working on a logo design, or layout ideas, or putting together a newsletter or brochure. Get all your possible approaches down on paper and then start to refine them, tweaking this idea or that.

You don't have to be a great—or even a good—artist to get your basic visual concepts down on paper. Circles, squares, and stick figures are perfectly fine. Besides, this process is for you, so you may never end up showing these ideas to anyone anyway.

Creative License

If you're working on a logo project, sometimes starting with words can be helpful. Look up words in symbol dictionaries, such as www.symbols.com, to get ideas for how you might represent the company's brand image.

The Five Ws

Another starting point is the five Ws:

- Who?
- What?
- Where?
- When?
- Why?

Reverse Type

One sure sign of an amateur designer is the tendency to put too much information on the page. Professionals, on the other hand, want to cut 75 percent of what is provided, to ensure enough white space on the page to make the design effective.

That is, who does this piece need to appeal to? What information does it need to convey? Where will it be read or received? When does it need to be done? Or when is the best time to distribute it? And why is this piece being created—what is its mission?

The five Ws can help you zero in on what is important and what is not, which will help you in sifting through the content, or text.

Thumbnail Basics

After you've sketched some rough ideas of what a layout or piece might look like, the next step is to refine them, or edit them. The next round of sketches are called thumbnails, mainly because they are often small versions of full-size pieces; they show the main parts of a printed piece.

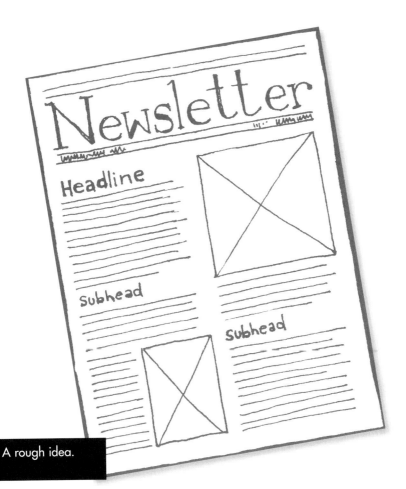

A rough idea.

For example, a newsletter thumbnail would show the following:

- The newsletter name
- The page layout
- Image placement
- The number of columns

Each page would have its own little sketch, so you or your client can get a better sense of what the finished product would generally look like. Now, there is no text in place, no actual images, but you can get an overall feel for how information flows on the page and what your eye will be drawn to first.

From thumbnails you then move to comps, short for comprehensives, which are more detailed and often in color.

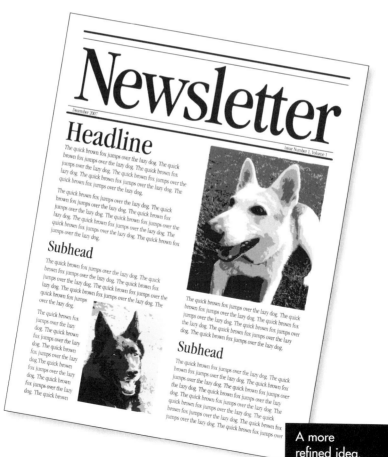

A more refined idea.

What Are Your Tools?

Whether you're interested in creating new designs yourself or in understanding the principles of design so you can better oversee the work of others, you'll need some basic tools to do your job well. Some of these include the following:

- A computer, or regular access to one.
- Some kind of layout software, or a combination of various graphic layout options, so you can design the collateral needed.
- Preview software so you can open designs for review, such as Acrobat Reader, which is free to download.
- A printer with color capability is best, but black-and-white will work.
- A flatbed scanner capable of scanning a full-page or larger-size document.
- A copier, preferably one that can reduce/enlarge and print on different paper sizes. Some machines can scan, fax, print, and copy, all in one.

Keep in mind that even if you lack one of these tools, you may have friends and colleagues who will give you access when you need it.

Desktop or laptop computers.

Sure you can invest in other tools, such as high-powered design software, but the truth is that it won't help you much until you learn more about typography, image selection, and page layout. So stick with the basics initially.

The Least You Need to Know

- Good design starts with a consideration of the target audience's needs and wants.

- Looking at well-designed, and not-so-well-designed, pieces can generate new ideas for how you want to approach your own projects, by helping to refine your personal style and preferences.

- Larger budgets do not guarantee better design work—great work certainly can be done inexpensively.

- Defining the five Ws will ensure you end up with a design that achieves the desired results.

- Paper and pencil are the best tools for brainstorming possible page layouts and logo concepts.

Printer and scanner.

- Picking computing sides—Mac versus PC

- Understanding software solutions

- Finding less costly supplies

- Choosing among printer options

Tools of the Trade

Golfers often joke that "if only they had the right equipment …," the implication being that their performance would be so much better if only they had the right club, glove, golf balls, or shoes. Although we may chuckle, the truth is, in graphic design, the right equipment *will* make a world of difference.

Armed with a reasonably powerful computer, design software, workspace with elbow room, and art supplies to fuel our creativity, new ideas often flow effortlessly, or at least more easily than if we were working today without a computer and printer.

Having basic design tools makes it possible for you to generate ideas and communicate them to others more effectively. So what are the basics? We're going to tell you.

Computer Equipment

To be able to create designs, or to manage other designers, you'll need access to a computer. That doesn't mean you have to own one, but you do need to be able to use it on a fairly regular basis. Doing without will actually cost you more in the long run because you'll have to outsource a much larger portion of each project to people who do have one.

If you currently don't have one and you're thinking about buying one, your first decision is whether to invest in an Apple Macintosh computer, a Windows-based or Unix-based PC.

Hello, I'm a Mac, and I'm a PC

Although PCs are much more common than Macs in the corporate world, the truth is that graphic designers are more frequently in the Mac camp. Many designers, and other Mac enthusiasts, believe Macs are preferred because Apple understands the value of design, and designers like that.

There are positives and negatives associated with each computer type. We list them in the following sections.

Macs

Pros:

- The common denominator in graphic design circles, so you should have fewer problems sharing files
- Fewer technical glitches and software corruption than PCs

Cons:

- More expensive than PCs
- Not as common in the corporate world, so file-sharing may be more challenging

PCs

Pros:

- Less expensive
- More software options available

Cons:

- Technical glitches more common
- Less intuitive *graphical user interface (GUI)*

Peripheral Devices

In addition to a computer, there are some add-on devices that are equally critical to the design process—working without them would be as difficult as working without a computer, really. They include these:

- Scanner—To scan documents and images in black-and-white and color
- Printer—Laser is best for layout and print quality
- Digital camera—For photographing larger items that you can't scan
- CD/DVD capabilities—To burn CDs (if not already built into the computer)
- Flash/thumb drive—To transport files to vendors
- Portable hard drive—To transport large files from computer to computer and to vendors

Software

Where there used to be a bevy of design software programs used by graphic designers, these days the one family of products used most frequently are in the Adobe family. Instead of buying and using several different design programs for various aspects of page layout, illustration, image manipulation, and web-page layout, you can invest in Adobe products and be confident they will all work together in harmony—even across Mac/PC platforms.

Reverse Type

Although Microsoft Word is not a page layout program, many people try to use it as such. Be aware that it has many limitations and may make your designs look less professional if you opt to use it.

Page Layout

One of the most basic of graphic design software programs is page layout, which enables you to place items onto a document page—blocks of text and images—using tools that assist with alignment.

Adobe's page layout product is InDesign, but QuarkXPress and PageMaker are two other very popular programs, too. And Microsoft Publisher is now bundled with some Microsoft products, providing an inexpensive, lower-end alternative that can work well in many situations.

Design on the Cheap

If you're a graphic design student, you may be able to purchase software packages for less than the average consumer. Check with your school's store or computing center to learn whether or not it has negotiated any special deals for students. Also check for student discounts online at stores such as www.AcademicSuperstore.com or www.journeyEd.com, where prices are considerably lower. Apple and other manufacturers also may discount products for students, so it never hurts to ask!

Vector (left) and raster (right) cross-sections show how they differ.

Vector-Based Software

One major element of any design project is the copy, or words, you'll use. The other is the graphic, whether it's a photographic image, drawing, painting, graph, or computer-generated image.

There are two ways that graphics can be created on the computer: vector-based and raster-based.

Vector-based, or object-oriented, images are created mathematically using a drawing program, resulting in a crisp, clean line

and edge, which is important when you're creating shapes such as boxes or triangles. Vector graphics use points, lines, curves, and polygons to create shapes using mathematical equations. Software for this type of graphic is known as drawing programs.

Raster-based, or bitmap, images are represented as a collection of pixels organized on a rectangular grid. This file format is intended for displaying photographic images. Software for this type of graphic is known as image-editing or paint programs.

Illustrator is Adobe's vector-based drawing program, but Corel Draw, Canvas, and Macromedia FreeHand are other popular packages.

Photoshop is Adobe's raster-based, image-editing program. Other packages you could choose include Corel Paint Shop Pro Photo and Corel Painter.

Image Manipulation

Many graphic design projects will require some kind of photographic image, whether as the central image of the piece or as graphic elements scattered on the page. However you intend to use photos, it's likely you also will need to modify or manipulate them in some way. That might include shrinking them, enlarging them, removing background images, tweaking the color, or a gazillion other possibilities. Image manipulation software makes such activities quick and easy—or at least easier.

Adobe Photoshop is one of the biggest players in this software category, although Corel Paint Shop Pro and GIMP (*GNU* Image Manipulation Program) are other options. Products other than Photoshop might not be as powerful, meaning they can't do as much, but they can tackle basic manipulation jobs.

Web Tools

If designing websites is in your future, you'll want to check into software programs Dreamweaver and After Effects, both from Adobe. Of course, other programs such as Microsoft Expression Web (partially built incorporating their former FrontPage technology) and a variety of open source code programs also are available to use.

Workspace

Technology has become central to the graphic design process, but an effective workspace, complete with furniture, also can impact your productivity.

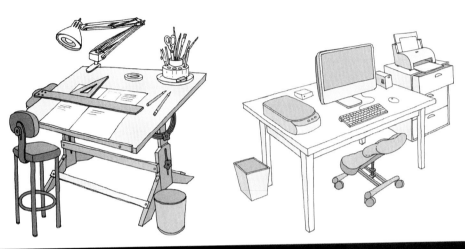

What a design studio had 30 years ago.

Today's modern studio.

Computer Desk or Drawing Table?

Before the advent of the computer and software developed for use by designers, the traditional studio used art supplies and drawing or drafting tables. Today most graphic designers work at a computer desk, because so much of the design process occurs right in front of the computer screen. But having an additional space in which to draw freehand can be useful, too, in which case a drawing or drafting table may be something to keep an eye out for.

In the end it all comes down to preference and your budget. If you're not sure you need a drawing table, don't buy one. It's not essential.

Light Box

A light box is a small square enclosure with an opaque top filled with light, tradition-ally used to look at slides. Nowadays it is more com-monly used to trace technical drawings, or to create line drawings by outlining ele-ments of a photo or other image.

A portable light box.

Light boxes are convenient and easy to transport, but perhaps unnecessary.

If you have a glass coffee table and a small lamp, you can place the lamp underneath the table and create your own. The effect of the lamp under the glass provides the same benefits as a light box. An easily accessible window with a great natural light source also can work in a pinch.

Nice-to-Haves

Over time, you may find a few extra items would be nice to have. While they may not necessarily make you more money immedi-ately, they may save your back and unchain you from your computer desk. We're talking about the fol-lowing:

Digital tablet.

- A comfortable chair with adjustable height and rocking capa-bilities
- A desk with a sliding tray to tuck away your keyboard and mouse when not in use
- Ergonomic wrist supports, for use with your keyboard
- An optical or roller-ball mouse, for improved ergonomics
- A Wacom tablet, which uses a wireless pen to draw illustra-tions or to take notes on a flat work surface

Art Supplies

While our primary focus thus far has been on identifying all the technology you'll need to succeed at graphic design, creating stunning designs is mainly an artistic process. Capturing your design, your artistic vision, on paper, and then on the computer screen, is your goal.

So of course, you'll need art supplies to begin the process.

Cutting Tools

At some point you'll need to draw a very straight line, trim paper, or cut mat board, all of which will require cutting tools.

Here are the key tools you need:

- Exacto knives
- A self-healing cutting mat, to protect surfaces you're working on and doesn't dull your blades
- Scissors
- An 18–inch-or-longer metal straightedge ruler, cork-backed

Design on the Cheap

Rather than pay high-end art-supply prices, check in the scrapbooking section of your local discount department store or craft store for self-healing cutting surfaces. They look like hard rubber and come in a variety of sizes—you'll want a larger one, rather than smaller. Of course, check online for bargains, too!

Pencils and Pens

Tools with which to draw, including pencils and pens, are essential design tools.

Although number-two pencils certainly work, most designers stick with mechanical pencils, because they never need sharpening.

These are other pens and pencils to have on-hand:

- Color markers—both thick and thin nibs
- Highlighters—for editing copy

- Ballpoint pens—Uni-ball black pens are a nice choice
- Nonrepro blue pens—for marking up designs without having it show on photocopies

Paints and Brushes

Some design projects call for soft watercolors, either to color the background or to illustrate one area of the design, so you'll want to have paints and brushes at-the-ready:

- Watercolor paints
- Brushes in a variety of sizes
- Gouche paints (water-based)

Printers and Output Devices

Once you've designed something, whether it's a direct mail piece, invitation, or logo concept, you're going to want to print it out to show your client or your boss. It's certainly easiest if you can do that by hitting "Print" on your computer screen; however, heading over to a local copy shop is always an option, too, especially if you need a color proof and your office only has a black-and-white printer or copier.

Determining Your Needs

If you don't already have a printer, or you're thinking of expanding your output options, here are some things to consider:

- If you expect to do a lot of black-and-white printing, a laser printer is your best bet in terms of quality.
- If you expect to do more color, however, buy a color copier so you can both print and copy in multicolor; many can be networked to other machines.
- Color printers have also come down in price in recent years, though the cost of ink should be considered before making the investment.
- Stick with laser printers if you can afford to, because less-expensive inkjet printers have a dot pattern that yields a lower resolution (meaning images are not as rich or crisp).

Of course, color is always more expensive, but buying your own color printer may save you a lot of time and money at the copy shop.

Papers

It is one thing to have a good printer, but if you don't use quality paper, your final product won't be up to the standards you expect. To start, depending on their weight and brightness, different papers reflect the colors printed on them in different ways.

What many people do not realize is that frequently the best paper for your printer is made by its manufacturer. Buy paper that is rated for your particular machine, meaning paper that the machine was designed to print on. Some printers, for example, were not manufactured to print on textured paper—so if you try to use textured paper, the toner or ink will simply flake off.

Or if you have a photo printer, for example, you'll get the best results if you buy photo paper rated specifically for your printer, and not a generic brand of photo paper.

Design on the Cheap

Consider using color paper for impact. When your budget is very limited, sometimes simply printing on a paper with color other than white will have a tremendous effect.

Printing to Other Media

You may be tempted to buy the smallest printer, the least-expensive printer, or the one that provides the best image quality on plain, white paper. But wait.

You'll probably be printing most frequently on white paper, but there may be times when you need to print on other surfaces, such as card stock or fabric. Check to see if the printer you like is designed to print on thicker card stock, or fabric, or cardboard. The more options you have, the less money you'll spend on taking your project elsewhere for production.

The Least You Need to Know

- Although Macs are considered the preferred computer of graphic designers, PCs have become so much easier to use that the differences are less apparent today.

- While graphic design is heavily dependent on technology, the most important part of the process—idea generation—generally occurs with paper and pencil.

- Among the key pieces of equipment you need are a computer, scanner, printer, and digital camera. Everything else you can borrow or work around.

- You'll need a computer desk to hold your computer, but you also may want a drawing desk and an ergonomic chair to support you, as well as a few other ergonomic accessories.

- Choosing a printer that can print on surfaces other than plain, white paper will, over time, give you more flexibility.

IN THIS CHAPTER

- Creating thumbnail sketches

- Using the eight design elements

- Applying the eight design principles

- Avoiding design missteps

CHAPTER 3

Concept Development

The best way to start any design project is at the beginning—with your client's needs. What exactly are you being asked to create and for what purpose? Knowing those two pieces of information will help you focus on what to do next.

Next, gather examples of similar pieces created by competitors. How do other companies in the same industry approach this design challenge? What works? What doesn't? In addition to gathering ideas about how you might approach your design project, you'll also start figuring out what you *don't* want it to look like, which is helpful, too.

Needs

As you begin thinking about what you're creating, you'll want to start with the need for your design. Ask your client the following questions:

- How does the firm like to work? What is the corporate culture like?
- Who are your clients?
- Who is your competition?
- Who is your audience?
- What is its purpose?
- What is the deadline?
- What is your budget?
- Are there any restrictions you need to be mindful of as you start sketching possible designs?

Once the basic needs are identified, you then prepare what's called a *design brief.*

A **design brief** is a clear statement of objectives for the project, listed in order of priority. The brief indicates how you plan to meet those objectives and includes a timeframe in which each step will be accomplished. The brief explains in detail what the design steps are as well as explain the approval and edit cycles which are part of the overall process.

Direction

Even if you're clear about what you're designing and why, your plan also will be defined by your budget.

- Is this a personal project you'll pay for out of your own pocket?
- Is it a labor of love for a nonprofit?
- Is it a new assignment you've been given at work?

Finding out how much money you have to spend will shape what you end up with, or at least it should. You don't want to waste time

developing an idea for a gorgeous four-color, multipage report when you only have $50 to spend to get it produced. Likewise, you don't want to limit your thinking to one-color printing if your department is expecting to spend thousands on this important piece.

Audience

In addition to understanding the purpose and budget for your design project, being clear about your audience is also crucial.

- Who, exactly, will be reviewing this information?
- What is their role? Will they be potential customers? Current customers? Potential volunteers? Students? Job candidates? Are they new parents? Grandparents? Tweens? Retirees? First-time homebuyers?
- When will they have need of the product or services being described in the design piece?
- What are the critical pieces of information they will want to know?
- How can you best show them the benefits?

The more background information you can gather on your target audience—the people this design needs to appeal to—the better the job you'll do in preparing something that speaks to them and gets them to take action. That action might be picking up the phone to make a dental appointment, transferring funds from a bank account to pay a utility bill, or visiting a website for more information or register for an event.

Armed with your art supplies, paper, and a need for a design, you're now ready to go. It's time to start sketching out ideas for how you'll approach your task on paper.

Whether you're working on a stationery package for a new business, a new logo, an invitation to a house-warming party, or something else entirely, you've probably been thinking about what you want it to look like. And while you may not yet have it totally finalized in your mind, it's time to start transferring snippets and ideas from your brain to the page (and, yes, we do mean a piece of paper, not a page on the computer screen).

From your first drawings, approaches will emerge that will lead you to your final design. That's the essence of concept development—taking your thoughts and ideas and putting them down on paper.

Thumbnails

So you know your purpose, your budget, and your audience. Now it's time to start drawing. Like doodling, take a piece of paper and start sketching the basic outline of the shape you think your piece will take. If it's an invitation to a wedding, you're working with several small, different-sized rectangles. If it's a poster, you've got a large rectangle. You get the idea.

Repeat that general shape several times on the page and then begin filling in what the overall look might be. Will there be a photo on the cover or just text? Will it fill the entire page, as background, or take up only a little space?

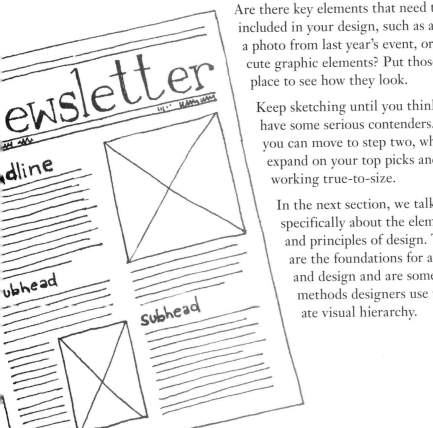

Are there key elements that need to be included in your design, such as a logo, a photo from last year's event, or some cute graphic elements? Put those in place to see how they look.

Keep sketching until you think you have some serious contenders. Then you can move to step two, when you expand on your top picks and begin working true-to-size.

In the next section, we talk more specifically about the elements and principles of design. There are the foundations for all art and design and are some to the methods designers use to create visual hierarchy.

Design Elements

If you're feeling a little overwhelmed by the design process right now, don't worry. There are some specific elements you can use to create your design, which are defined below. These often work singly or coupled together. We include images that combine elements and principles to show you how they work.

Point

The first element is the point. A point is a single spot on a page. A point can be typographic, like a period or punctuation mark, or it can be a graphic element, and it doesn't have to be circular in form. It can serve as a foundation or building block for a design. The natural tendency is to put a point in the center of the design, to become the focal point. Moving the point off-center, however, shifts the focus to wherever the point is.

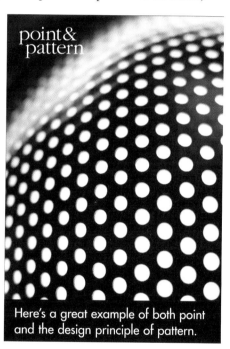

Here's a great example of both point and the design principle of pattern.

You don't have to use a point alone, though. It's merely one design tool to lead the reader's eye to where you want it to go.

Line

Lines are another design element that can be used to show direction—where you want the eye to go—and movement. Vertical lines give elegance and elongation to the page, while horizontal lines create a more relaxed feel; curved lines suggest an organic theme. Repetition of lines, or other elements, can be used to also create patterns.

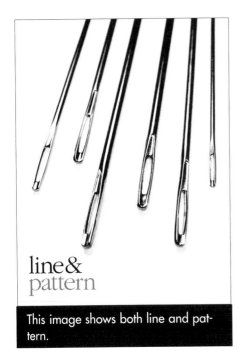

line&
pattern

This image shows both line and pattern.

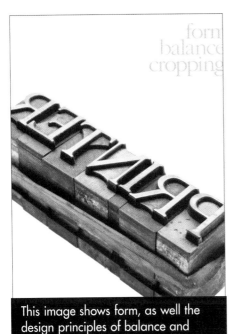

This image shows form, as well the design principles of balance and cropping.

Shape

A shape is exactly what it sounds like: circles, squares, rectangles, and triangles are all design building blocks. Repeating shapes or grouping them in an organized method works to create patterns, too.

Form

Form is another design element that has to do with the appearance of depth. Form gives a three-dimensional perspective, sometimes through drop shadows and tone. Physically occupying space or giving the illusion of occupied space in a flat, two-dimensional surface.

Form is the shape of text, images, and white space, also called void, on a page. By using graphic elements or white space the designer can lead a viewer around a page. Because we are so accustomed to getting information quickly, form can help a viewer see pertinent elements.

Tone

When adding tone to a design, you're adding a sense of lightness and darkness. The most common way to do this is through gradients, where an area goes from light to dark or from darker to lighter color. Using shadowing and patterns in a lighter tint can also add tone—the overall goal

is to add depth to a piece. But be judicial in your use; to overuse these techniques looks amateurish.

Texture

Another design tool is texture, which officially is defined as the character of a surface. Texture on paper adds dimension, through repeated dots or lines, for example. Be careful when selecting textures, decide if you're using a textured paper or adding it in the design. Using many different textures can be confusing and work against the overall design of a piece.

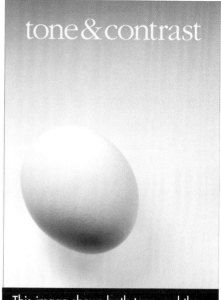

tone & contrast

This image shows both tone and the design principle of contrast.

Color

Any kind of color adds impact and interest to objects and design.

While there are thousands of shades of color, designers approach them in three major categories:

Color, Pattern, & Texture

This image shows texture, color, and pattern.

- Primary colors—red, yellow, and blue
- Secondary colors—green, purple, and orange
- Tertiary colors—all the colors between the secondary colors on the color wheel

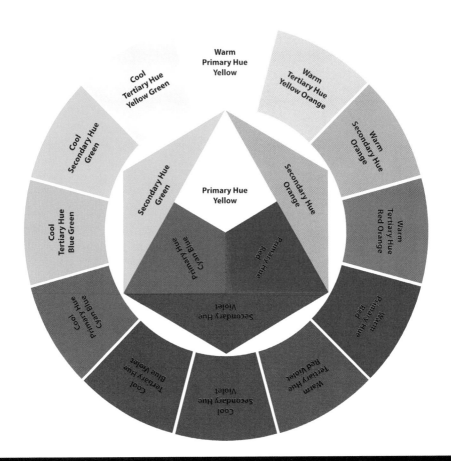

This color wheel shows the primary colors in the inside section, secondary colors as the ring circling the triangles, and the tertiary colors in the ring circling all.

Creative License

Brighter colors make elements of a design seem larger, while cooler colors make them seem smaller.

Letterform

Text, or copy, and blocks of text are considered letterforms, and are an additional element to be considered as part of your design. Nearly all designs include some amount of letterform as a way of communicating with recipients.

Letterform can be used as a graphic element, such as with enlarged letters, or as a means of conveying information.

> This image uses both shape and letterform.

Design Principles

Design principles are the rules that suggest how design elements should be arranged to make the resulting design both pleasing and functional.

Reverse Type

Drop shadows and outlines can be very tacky and hard to read.

Drop shadows can be an effective technique with shapes and products featured in your design, but don't go overboard with drop shadows on text. Over using drop shadows and outlined type looks amateurish and is hard to read.

Figure-Ground

The first principle is figure-ground: the figure refers to the main focus within your design, and the ground is the area that surrounds the figure. Either one can be dominant, depending on where you want the viewer's eye to focus.

See how line, shape, and figure-ground all work together in this image.

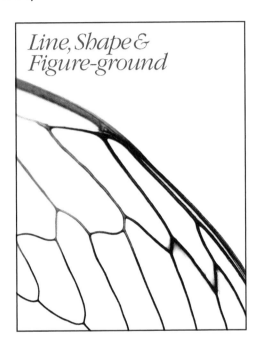

Line, Shape & Figure-ground

Balance

Elements in a design can either be *symmetrical* or *asymmetrical*. Large or small, all work in this principle. For example, when using a large object and small object together on the same page, the proximity to one another can be well-balanced or poorly balanced. By placing them close together, the balance is poor. If you allow more space between the objects the balance is more even.

Symmetrical elements are equally balanced parts that reflect each other, while **asymmetrical** elements are not balanced.

Asymmetrical elements are often used to create visual excitement, by calling attention to certain elements. Designs that are asymmetrical are generally divided into thirds, rather than halves.

When using tone to create asymmetrical balance, use the rule of thirds for your composition. By that we mean, the tone or pattern should be anywhere from ⅓ to ⅔ of the design—one third of the design might be colored darkly where the other third would be lightly colored.

Contrast

Contrast refers to the relationship between the elements of design. The greater the difference between the two elements, the greater the contrast, as in the case of size—big versus little. Colors can provide contrast, too, with complementary colors—opposites on the color wheel—providing the greatest contrast, and coordinating colors having the least contrast. In the next figure, the color yellow works better with the purple color because the contrast is greater than with the green color. The green text block is more difficult to read because the green and yellow are too similar in contrast.

Purple words on a yellow background have high contrast and are easier to read.

Color choice can make all the difference in readability.

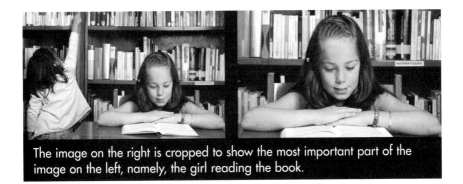

The image on the right is cropped to show the most important part of the image on the left, namely, the girl reading the book.

Cropping

Although we most often hear the term cropping with respect to photography, it really refers to the process of selecting the elements of design we want the user to see. It's generally used to zero in on the most important subject within an image.

Hierarchy

The principle of hierarchy determines how important or dominant an element or set of elements is to a design. The most important elements are at the top of the hierarchy, while less important elements are at the bottom. Size, weight, and scale all can contribute to creating a visual hierarchy.

The type is the top-most important element in this image, but the image element at the bottom is equally important.

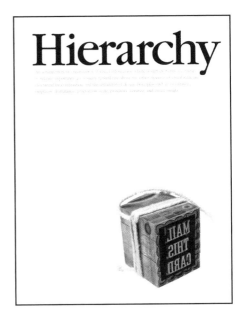

Scale

You most often see scale used for exaggeration, such as in carica-
tures, where certain features of a politician, for example, might
be disproportionate to his or her body. Scale refers to how large
an object is in relation to other objects in the design, and is often
used to inject humor, by making smaller objects oversized, for
example. Scale can also be used to show intricate detail that is not
easily seen at a 1:1 ratio, but is also a technique used in technical
drawings that show an "exploded" or enlarged section.

This image uses both scale and shape.

Proportion

Proportion within a design deals with the relationship between
various elements and whether they are pleasing to the eye. It
comes down to a mathematical formula, with four ratios being the
most pleasing:

- 3:2
- 5:2
- 8:5
- 1:1.62

These are guidelines and can be kept in mind when visually assessing your design. Most designers do not use rulers or other measuring devices to guarantee these proportions, but they are rules learned and practiced over time.

This image shows both form and proportion.

form& proportion

Pattern

As it suggests, the principle of pattern deals with the repetition of elements, such as lines, points, or shapes, as you saw previously. If you add patterned paper, don't forget to count that as well. Patterns, if over used, are not attractive and show the mark of an amateur.

Following the principles of design regarding the use and placement of the various elements should help you decide when a design "works" and when it doesn't.

The Least You Need to Know

- Almost every design draft begins with pencil on paper, as rough, small sketches called thumbnails. Once you've narrowed your choice to a few thumbnail options, begin creating a true draft, or composition, for review.

- There are eight elements of design or tools you can use to create a design masterpiece.

- You put the various elements together using eight design principles, or rules of design, to create an eye-pleasing composition.

CHAPTER 4

How to Make an Impact

In addition to making information more interesting and easier to understand, graphic design also aims to make messages stand out, in a good way. Good design is eye-catching and reflects positively on the company sponsoring the design, whether it's a book, a magazine ad, a poster, or something else. Smart, savvy design gets noticed.

Design that is new and different also gets noticed, because it stands out as "not like the others." Now, in most cases, taking a different approach can lead to innovative design, but in some cases, zigging when others zagged can be disastrous.

As you begin roughing out your design concepts, make sure the differences in your design reflect the unique needs of your client or audience, and that you're not taking the opposite approach simply to be different.

Designing the Unexpected

So how do you know what is different from the norm? Study what already has been done. Then choose one or more ways to make your design stand out from the pack.

Brainstorming

To learn what the standard approaches to design are in your industry, study the work of designers at other companies. How do your competitors typically approach their brochures, flyers, ads, annual reports, website, or signage, for example? Call and request an information packet from them. Tear out magazine ads featuring their products. Visit their websites. Then line them up to study the similarities and differences.

Be on the lookout for designs that you respond to, that you think are spectacular. Make a swipe file, or add to one you've already started, and study what it is about others' designs that you love.

Annual design books and awards issues of graphic design magazines such as *Communication Arts, How,* and *Print* are additional sources of ideas and case studies.

Examples to Get You Thinking

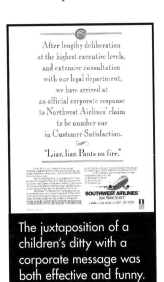

The juxtaposition of a children's ditty with a corporate message was both effective and funny.

There are an almost unlimited number of strategies you can use to differentiate your designs—we'll give you some in a minute. But to start, choose just one way to set your design apart. It could be in the colors you use, the images you select, the size of your design, how you print it, or even how you deliver it.

One great example of an unconventional design that certainly got noticed was a recent Domino's Pizza's annual report. The report itself looked much like the glossy, high-end reports most investors receive every year, but one of Domino's Australian franchisees took extra effort to make their annual report stand out, by delivering each one ensconced in a pizza box.

But delivery is only one way in which your design can stand out. There are plenty of others. Humor is frequently effective. Southwest Airlines used it to reflect its corporate culture, and to catch the attention of business travelers in its full-page *Wall Street Journal* ad back in 1992. The eye-catching use of a pull-quote made its point and had its target audience laughing its, um, pants off

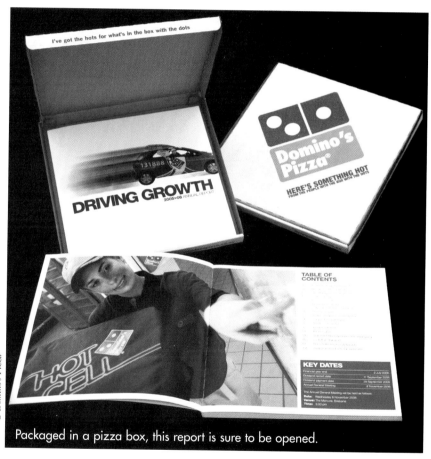

Packaged in a pizza box, this report is sure to be opened.

© *Domino's Pizza*

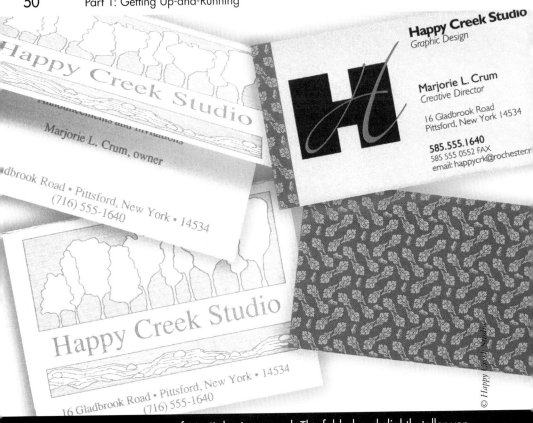

Happy Creek Studio
Graphic Design

Marjorie L. Crum
Creative Director

16 Gladbrook Road
Pittsford, New York 14534

585.555.1640
585 555 0552 FAX
email: happycrk@rochester.rr

© Happy Creek Studio

Here are two versions of Marj's business card. The folded and slightly taller version was her first card, which she used for 10 years; then she redesigned the card but still wanted visual impact, so she printed on both sides.

Strategies and Tools

Now that you've seen some examples of unconventional designs that worked, let's talk about specific ways you can make your own designs stand out. These strategies and tools are some of the most frequently used, but are certainly not the entire list of options available to you.

Size

For whatever you're working on, there is presumably a standard size. If you're designing stationery, most pages are printed on 8.5×11-inch paper in the United States. Liner notes in CD cases are also a standard size to fit inside the jewel cases. Brochures are

frequently slightly larger than 8.5×11 inches, especially if they have a pocket in back to hold slip sheets. Postcards are generally 4×6 inches, but they can be larger, too, depending on what you want to spend on postage. Tri-fold brochures are almost always 8.5×3.67 inches, and business cards are typically 2×3½ inches.

However—and that's a big however—you do not have to produce your materials in the standard, conventional format.

To be different size-wise, you can go big or go small. Depending on your budget, you may not have the option of going bigger, because it might increase your production costs, but you can probably go smaller without much additional cost, if any.

For example, the tried-and-true business card is printed horizontally on a 2×3½-inch cardstock. That's the standard approach, and it has worked well for decades. But if you'd like your business card to break from the norm, here are a few alternatives:

- Print on both sides of the card
- Print vertically
- Design a square, versus rectangular, card
- Use die-cutting to make an impression

A letterpress business card printed vertically.

One potential downside of an unusual-sized business card is that people who file them away or run them through a business-card scanner may have more difficulty retaining your information. Take that into consideration every time you consider moving away from the standard—will it negatively impact your business, or your employer's business?

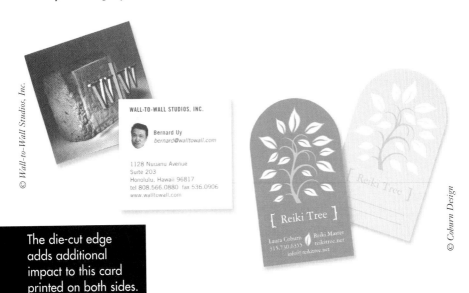

The die-cut edge adds additional impact to this card printed on both sides.

© Wall-to-Wall Studios, Inc.

© Coburn Design

Substrate

Another way to stand out from the crowd is to print your design on something other than paper, which we refer to as a substrate, or a layer you'll design on.

If you're designing a folder cover, for example, you might decide to print directly onto cardboard, rather than slipping a sheet of paper into a three-ring binder. Or you might print onto fabric and then wrap it around the cover for effect.

You can produce your designs onto file folders, mugs, mouse pads, boxes, signs—you name it—as long as you have a way to adhere it to the surface, or substrate.

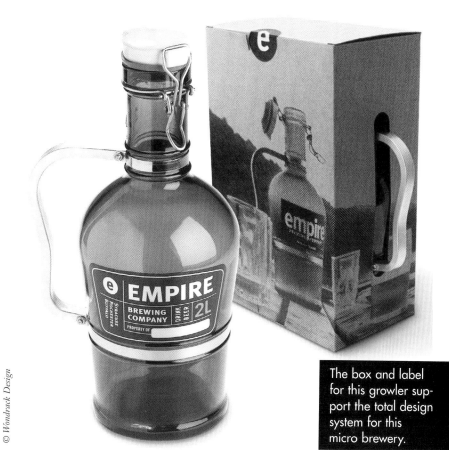

© Wondrack Design

The box and label for this growler support the total design system for this micro brewery.

Printing

While most of the printing you do will likely be on an office printer or copier, or at a commercial printing company, you have some other printing tools, too.

Letterpress printing, which is an older printing technology offered by a dwindling number of craftspeople, uses metal letters that are pressed into paper to transfer the ink. The result is a more formal, traditional look and feel, with the added benefit of texture, formed when the metal letters create indents in the paper.

Creative License

If you decide to experiment with letterpress for a formal invitation or special certificate or document, you'll get better results with premium, high-rag-content papers.

Where letterpress can be more formal, rubberstamping—another form of printing—can be more casual and homespun. You can use rubberstamps to form letters or to add graphic elements for decoration or emphasis. Depending on the shape of the letter you choose, you can work with stamps that are solid, transferring letters that are color-filled, or outlined, in which case you can then color in the outlines of the letters the stamps have made.

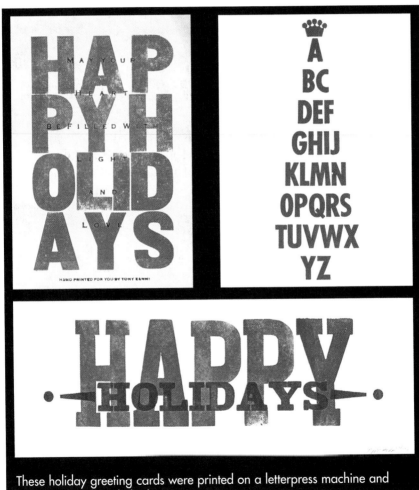

These holiday greeting cards were printed on a letterpress machine and present a hand-made look.

Design on the Cheap

While you may assume that hand-producing designs will be more cost-effective, that is not always the case. The additional labor and supplies required to, say, rubberstamp several hundred posters may exceed the cost to have a quickprinter produce them.

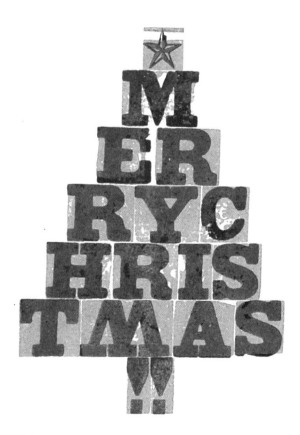

Another letterpress card that resembles a rubber stamp technique.

Binding

When producing booklets, pamphlets, or reports, one component you might consider altering is the binding. Sure, Kinko's can offer you tape binding, coil binding, spiral binding, among others, but how about a hand-sewn binding?

Grommets are becoming more popular as a way to connect several cards or pieces of material. Perhaps grommets might work as a binding on something you're working on.

One of the most eye-catching bindings we've seen was created by a regional Boy Scouts of America council, which bound its report using twigs. Unusual? Yes. And perfect for its audience.

Packaging

If changing your design would interfere with its effectiveness, perhaps changing the packaging or delivery will boost its impact.

Dimensional mail refers to packages of an unusual shape—also called lumpy mail. Rather than flat envelopes, some direct mail companies now enclose an item with weight, such as a pen or golf tee, that ties into the theme of the message.

In the direct mail industry, *dimensional mail* is now all the rage and has been around for some time.

Packages that obviously contain something special are more frequently opened by recipients; people want to see what they got!

So instead of mailing just a brochure or flyer, consider enclosing one of your products, or a promotional item to keep your organization top-of-mind.

The Least You Need to Know

- Study the standard or normal approach to certain materials or products in your industry to understand what's typical. Then consider how you might make your design atypical.

- There are a number of ways to make your design stand out. Altering the size, shape, printing method, surface, or type of binding are good places to start.

- Doing more of the work yourself will not necessarily reduce the cost of your project and, in some cases, may actually increase them.

- Don't try to make every aspect of your design different or unusual, but just focus on one or two ways.

PART 2

Incorporating Words

After you've sketched some possible rough layouts, you'll hear all about typography, or what many people call "fonts." We show you how to use them to enhance your design. In addition to getting the lowdown on the four basic typefaces all designers use, you'll hear some recommendations for choosing from among the thousands of options you have available, based on your design, your audience, the message of your piece, and the characteristics of the various typefaces. You'll also learn about visual hierarchy and how it can make or break your design.

Why Type Is Important

When you hear the phrase "graphic design," you probably picture beautifully laid-out brochures, stunning direct mail postcards, eye-catching newsletters, and other visual communication tools. Design generally is associated with the visual elements on the page—the layout, the colors, and the pictures or decorative icons. For most nondesigners the text fades into the background. And yet the type—the letters—and how it is presented, can make or break a designed piece.

A lot of graphic design deals with making something visually appealing. However, you need to make sure your message is communicated effectively in the piece you are creating. Most of the time, this is done through the use of words. But how do you make sure your words both fit into your overall design yet stand out enough to be noticed? In a word, typeface.

You should also be aware of the debate between the terms "type" and "font." Both terms are used interchangeably, however most designers of type refer to all the characters in a typeset as type. Font is a term that serves more as a reference to the software, installed into a computer, that mathematically describes each character. Each use is hotly defended as being correct, and many nondesigners don't see the need for specific use.

Characteristics

You're going to get tired of hearing that with any designed piece—whether an invitation, graduation program, flyer, or poster, for example—you should start by considering your audience. What style and typeface would be most appropriate for them?

If you're appealing to an older audience, for example, such as through a fundraising letter or alumni publication, you'll want to be sure you use a typeface older eyes can easily make out. For corporate executives, a more staid, conservative typeface will be most familiar and comfortable to them, while artists may respond to a more funky, contemporary type. What are the demographics and personality types of the people you are trying to communicate with?

Without tradition,
art is a flock of sheep
without a shepherd.
Without innovation,
it is a corpse.

—Winston Churchill (1874–1905)

Without tradition,
art is a flock of sheep
without a shepherd.
Without innovation,
it is a corpse.

—Winston Churchill (1874–1905)

See how the serif type on the left seems to go with the quote better than the more modern sans serif type on the right.

Start with your audience.

You'll notice as you start to sift through the thousands of typefaces on the market that there are four major categories of type: serif, sans serif, decorative, and script. Which category a particular typeface falls into depends on what it looks like, rather than how it is used.

What Makes a Typeface Good?

All typefaces can be useful and effective when placed in the right design. Said another way, on their own, well-designed typefaces are all good. But when used inappropriately, they can become bad.

In addition, type is "good" when it is easily read—when the typeface does not distort or interfere with legibility and readability. Even if the type looks great with your design, if your audience can't read the message, it is ineffective.

Anatomy of Type

Let's dissect a single piece of type to show you its individual parts:

Ascenders and *descenders* give shape to words and help improve readability. They also give distinction to letters, to help readers identify them without much effort.

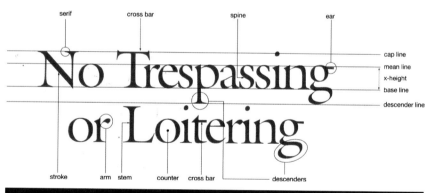

Every letter has distinct parts.

Ascenders are the piece of a letter that rise above the x-height, or the top of a lowercase letter. **Descenders** drop down below the baseline, or bottom of most lowercase letters. The letter "t" has an ascender, and the letter "g" has a descender, for example.

Use of Glyphs

When you choose a typeface for a particular design project, you do so based on the look of many of the letter characters in that typeface's alphabet. Each of those characters, and some letter combinations, are called glyphs.

What Is a Glyph?

The formal definition of a glyph is a "character in a type set." This includes letters, numbers, punctuation marks, *swashes*, and some combinations of letters, which are called *ligatures*.

When They Are Used

Glyphs are used as a more elegant solution to plain type. Ligatures are more appealing to the eye, because the spacing is proportional to each letter, and special characters can add emphasis and style.

When you type letters on a page in a standard word-processing software package, the space between each letter is even. While you might think that would make the letter combinations seem more in alignment, the reverse is actually true. Even spacing between letters of differing widths causes gaps that are noticeable. Glyphs, or ligatures, and manual spacing can solve that problem.

Swashes are more ornate versions of letters. Parts of the letters are usually extended, adding extra embellishment to a letter's form.

Ligatures are combinations of two or more glyphs or characters presented together as a single form. They include combinations such as fi, fl, ffi, ffl, th, and sometimes st, ck, and cky. These combinations are unusual in that when presented alone, the spacing between is out of proportion, and the characters look too far apart. When treated as ligatures, the space between them is made proportional.

A glyph might be used as the first character in a line of text, for emphasis or to look more professional. Glyphs are generally not used in body copy or text, such as what you'd find in a textbook or a novel unless they're special treatments used for chapter headings. But they are especially grand when used correctly in

headlines (such as a newspaper or magazine heads) or on posters. Anywhere that the type is large and prominent is an ideal place to use special characters.

Ct sp ff ff fl fl fflffl

QQ ee rr tt't zz

Garamond Premier Pro

ff gy fi fl fl ffi

Th th th Eg Mc St.

Zapfin

Samples of ligatures and swashes from two different typefaces.

The stars are putting on their glittering belts.
They throw around their shoulders cloaks that flash
Like a great shadow's last embellishment.

Wallace Stevens (1879–1955)
U.S. poet, from *The Auroras of Autumn*

The capital "T," called a "drop cap," makes a nice focal point for the verse.

Creating Impact

Other ways to create impact using better spacing between letters is through *kerning* and *leading*.

Although consumers probably will not notice the pains you took to ensure that spacing between letters was optimal, the changes can be dramatic.

❝I pledge allegiance,
to the Flag of the United States of America,
and to the Republic for which it stands,
one Nation under God, indivisible,
with liberty and justice for all. **❞**

❝I pledge allegiance
to the Flag of the United States of America,
and to the Republic for which it stands,
one Nation under God, indivisible,
with liberty and justice for all. **❞**

Notice how the same text looks more finished in the top version with the use of proper kerning, glyphs, and leading.

Kerning involves the horizontal spacing between letters. You can adjust the kerning to make the letters closer together or farther apart. This is not the same as tracking.

Leading (pronounced "ledding") deals with the vertical spacing between lines. You also can adjust the space above and below a line, to tighten text, or to add more white space on the page.

Classifications

As we said before, typefaces fall into one of four categories—serif, sans serif, decorative, and script—based on their appearance.

Serif

Serif typefaces have letters with little feet, or finishing touches, on the end of the letter. Examples of serif typefaces include Caslon, Garamond, and Times New Roman.

Traditionally, serif type was considered the style that was easiest for our eyes to read and decipher. However, with increased use of the web, where serif typefaces are less prevalent and sans serif becoming more common, that rule may change.

The quick brown fox jumped over the lazy dog.
Caslon

The quick brown fox jumped over the lazy dog.
Garamond

The quick brown fox jumped over the lazy dog.
Times New Roman

Notice the slight serif variations on each of these faces.

Sans Serif

Sans serif type has no feet or extra embellishments. Examples include Futura, Helvetica, and Univers.

The quick brown fox jumped over the lazy dog.
Futura

The quick brown fox jumped over the lazy dog.
Helvetica

The quick brown fox jumped over the lazy dog.
Univers

Notice the differences in the crossbars and weight of these three sans serif faces.

Decorative

Decorative typefaces consist of fancy letters. Because they are often hard to read, designers may use one in a word for emphasis or impact, but not for all the letters—it becomes illegible.

Take a look at Critter and Ouch typefaces. They consist of animals and injury-related characters in the shape of letters.

THAT CRAZY QUICK RED-BROWN FOX... YOU KNOW THE REST.

You might use one of the letters in Critter to form the "C" in a word, or the first letter, perhaps; but using the animals repeatedly would make the words extremely hard to read, and the shapes would lose their impact.

Script

Script typefaces look like calligraphy or handwritten words.

Type that looks handwritten is often used to suggest a more casual tone or event. And calligraphy is common for formal announcements.

Thou quick bronze trickster, where is thy slothful hound?

Doesn't this type look like someone might have written this long ago?

Readability and Legibility

How easy a typeface is to read depends on the x-height of the letters. The x-height is the height of the top of the lowercase letters in the type family. Refer to Figure 2 and Figure 9 for a visual reference.

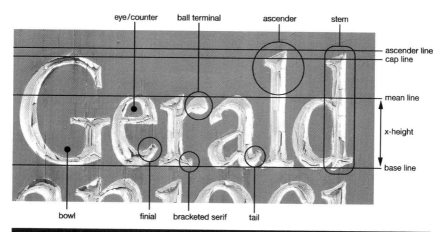

Type anatomy refers to all forms of type, even that on a sign.

X-Height

A typeface with a high x-height indicates that the lowercase letters in that type family are higher than most lowercase letters, while a low x-height suggests the opposite. This is useful information, because a larger x-height can aid in readability by making the letters easier to see.

Sly as a fox. **Sly as a fox.**
Quick as a wink. **Quick as a wink.**
Every dog has his day. Every dog has his day.

See how the x-height, and the character width, varies with each of these serif and sans serif faces.

> Weight has to do with how much ink appears per letter (density) on the page.

A dog in desperation will leap over a wall.
—*Chinese proverb*

Weight

Another factor that affects readability is the weight of the letter, or how thick or thin the letters are. The thinner the weight, the lighter the color on the page, and the harder the letter is to read.

Emotional Impact

In addition to affecting how easy a block of text is to read, some typefaces also evoke emotion. The way some letters are presented brings back memories and the associated emotions, causing us to have an emotional reaction to some designs.

For example, typefaces similar to textbook copy may cause us to become tense, remembering those late-night study sessions in high school or college.

Or heavy black lettering associated with formal documents and diplomas may bring back memories of the joy and relief of graduation. It's different for each of us, but some typefaces do evoke a reaction.

Typeface gives us an impression, a visceral reaction, even without the meaning of the words being read.

> Notice the heavy, ornate type used on this diploma.

Atomic Structure, Periodic Table, Electronic Structure

Lorem ipsum dolor sit amet, consectetuer adipiscing elit. Phasellus vitae enim. Fusce a quam. Aenean fringilla dictum nulla. Mauris sodales massa ac dui. Ut nunc tortor, sollicitudin at, mollis at, porttitor quis, odio. Nullam vitae tellus. Sed et est vel diam accumsan malesuada. Nulla elementum justo ut urna. Aliquam scelerisque semper odio. Duis blandit.

OBJECTIVES

Mauris ac purus. Mauris rutrum dignissim diam. Duis eu ante vel nisl tincidunt viverra. Mauris ut urna. In dignissim purus vitae tortor. Cras ac mi ultrices neque volutpat suscipit. Ut leo magna, tempus sed, aliquam sed, eleifend a, eros. Curabitur porttitor velit sit amet magna malesuada posuere. Sed eu dolor. Vestibulum lectus ligula, scelerisque sit amet, faucibus at, dignissim ut, ante.

Donec non risus. Proin ac dui non ipsum vulputate suscipit. Morbi libero. Class aptent taciti sociosqu ad litora torquent per conubia nostra, per inceptos hymenaeos. Etiam at est consequat posuere. Quisque tempus. Nulla quis lacus. Pellentesque habitant morbi ... ac turpis

Ten Principles of Economics

Lorem ipsum dolor sit amet, consectetuer adipiscing elit. Donec urna. Suspendisse potenti. Phasellus non dolor. Vestibulum lectus velit, blandit si, net, tristique quis, fermentum nec, est. Nullam eleifend leo ut sapien. Vivamus ius urna. Morbi at risus. Quisque nec sapien non diam pretium gravida. Etiar nentum massa eu velit. Suspendisse felis magna, sagittis nec, ultrices a, lacinia nunc. Proin sollicitudin.

orbi sollicitudin nunc. Mauris a dui suscipit orci varius elementum. Nullam r. Suspendisse elementum, nulla a ultricies porttitor, sem nisl tempor t molestie sem tellus sed metus. Fusce blandit. Nullam ac dui. Mauris y. Integer tempor. Vestibulum a turpis vitae mi cursus sagittis. Proin eget velit varius luctus. Phasellus id purus sit amet urna gravida aliquam. e felis. Sed sed pede. Quisque eget diam. que aliquet luctus ipsum. Aenean sodales ipsum non urna. el ligula. In et mi. Suspendisse pede odio, ultricies eget, mattis sed, , velit. Mauris in justo. Aenean sed libero vitae ante gravida blandit. porttitor non, lobortis et, venenatis vel, magna. Vestibulum at ula ornare volutpat. Nunc tortor risus, dignissim id, molestie nisl. Nulla facilisi. Suspendisse potenti. Donec egestas risus sed natis. Maecenas est ipsum, tincidunt sit amet, consequat vamus tincidunt. Ut fermentum N ac neque

A couple of textbook pages.

Managing Type

The more design projects you undertake, the more likely you are to obtain many different typefaces. Typefaces are the equivalent of some people's shoe fetishes—you simply can't have too many. Only, like shoes, typefaces take up a lot of space; they can significantly slow down your computer's processing speed if you try to keep them always available on your hard drive.

Because a type family consists of more than just the one typeface—it also includes several variations, such as bold, italic, bold italic, Roman, narrow, and others. These varieties should be used for emphasis, rather than the Bold, Italic, or Underline buttons on your computer menu bar.

Reverse Type

One sign of an amateur designer is someone who chooses a typeface and does not buy the bold or italic versions with it. Using the Bold and Italic menu bar items does not produce the true bold and italic look you want, only a faux (and phony) finish.

Roman *True Italic* *Faux Italic*

Buy Versus Shareware

There is no shortage of typefaces on the market, with new ones being created every day. Some are available for purchase through type foundries—companies that make money designing new typefaces; others are available through shareware.

If you buy from a type foundry, such as www.myfonts.com, or from Adobe, at www.adobe.com/type, you'll pay around $30 for a single set of type—the alphabet, maybe a standard ligature set, and punctuation, in one style.

Buying a family, with all the style variations, will cost you more like $100 to $200 and above.

You also can economically buy CDs of stock images that include type. The only downside with such CDs is that you'll typically receive only a small set of styles within one family. That is, you may only get one version, like a roman or a bold version, but you won't get all the many variations that typeface has available, such as roman, semi-bold, semi-bold italic, bold, bold-italic, and so on.

Shareware is certainly another source of typefaces, but many do not provide punctuation or ligatures. The cost of shareware varies, and is often whatever you elect to pay the seller.

Juggling Many Typefaces

The best way to manage your many typefaces is to use a font management program, which enables you to offload typefaces you use infrequently. You still have access, but you won't take up valuable processing, or RAM, with a type family you only use once a year for your company's holiday card.

What to Avoid

Besides choosing a typeface that doesn't match the piece being designed—such as selecting a whimsical, juvenile typeface for a retirement-party announcement. Also avoid using a typeface consisting totally of all capital letters for large bodies of text.

The problem with all caps is that it suggests that the person speaking is shouting, and it's hard to read. If emphasis is your intent, use a bold version from the same type family, for example, Cheltenham bold or Cheltenham semi-bold.

Creative License

When most graphic designers have over 100 typefaces on their computer, that's the time to invest in type management software, such as Linotype's FontExplorer, Extensis' Suitcase Fusion, or FontAgent Pro. The investment will give you immediate access to the type you want, without the need to upgrade your computer's processing speed.

The Least You Need to Know

- The typeface—commonly, but mistakenly, referred to as a font—you choose can significantly alter the look and feel of your designed piece.
- Professional versions of typefaces have improved letter proportions and scale, which becomes evident during the printing process.
- There are four basic typeface categories: serif, sans serif, decorative, and script.
- The color of the paper and ink you choose also affect readability and legibility. The more contrast between the two, the easier the letters are to read. The less contrast, the harder they are to read.

- Making type choices first

- Matching your type to your brand

- Buying whole type families

Choosing a Typeface

With tens of thousands of different typefaces to choose from, how do you select just the right one for your particular design project? The truth is that some designers often make the mistake of waiting until they have a rough design concept and copy in-hand before looking at possible typefaces. However, choosing a typeface should be an early decision and part of the design process.

That's because the typeface you choose either supports and strengthens your design or it interferes with it. As you heard in Chapter 5, different typefaces evoke different emotions. You want to select a typeface that enhances the look and feel of your overall design piece, and you start, as always, with your audience.

Knowing Your Market

In addition to considering your message and what typeface will best support or enhance it, you also need to consider your target audience when making your selection. How old are the audience members? What language do they speak regularly at home? How familiar are they with the product or service you are telling them about?

As you look at the four major typeface categories and zero in on the one category that makes the most sense for your project, you then can start to sort through which type families best reflect the look and feel you're trying to evoke with your design. Are you suggesting a historical theme or message? Do you want a traditional, conservative vibe, or a trendy look and feel? The more subtleties you can define about your audience, the better the choice you can make in selecting a typeface.

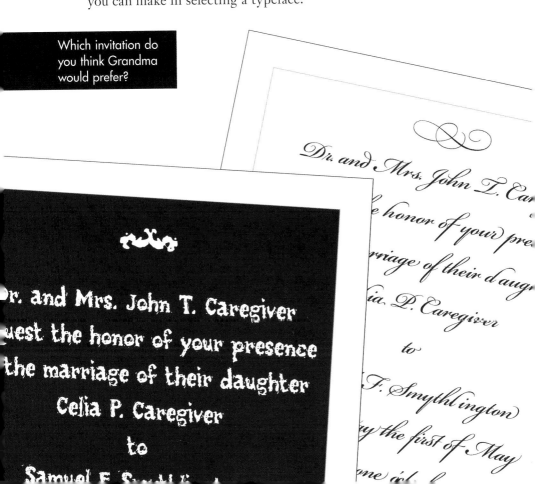

Which invitation do you think Grandma would prefer?

r. and Mrs. John T. Caregiver
uest the honor of your presence
the marriage of their daughter
Celia P. Caregiver
to
Samuel F. S

Dr. and Mrs. John T. Ca
e honor of your pre
rriage of their daug
ia P. Caregiver
to
F. Smythlington
y the first of May
ne

How Type Is Used

Your audience, the people you are creating the designed piece for, likes to be given a hint regarding the purpose of the information. That's what the typeface can do.

In addition to reflecting the message your design aims to communicate, the type you choose should also fit with your organization's overarching brand image.

Color and Paper

Although black type on white paper provides the greatest contrast and best readability color-wise, you have a huge range of options when it comes to paper and ink colors.

Can A Dog Really Catch A Fox?

Lorem ipsum dolor sit amet, consectetuer adipiscing elit. Phasellus vitae enim. Fusce a quam. Aenean fringilla dictum nulla. Mauris sodales massa ac dui. Ut nunc tortor, sollicitudin at, porttitor quis, odio. Nullam vitae tellus. Sed et est vel diam accumsan malesuada. Nulla elementum justo ut urna. Aliquam scelerisque semper odio. Duis blandit.

Can A Dog Really Catch A Fox?

Lorem ipsum dolor sit amet, consectetuer adipiscing elit. Phasellus vitae enim. Fusce a quam. Aenean fringilla dictum nulla. Mauris sodales massa ac dui. Ut nunc tortor, sollicitudin at, porttitor quis, odio. Nullam vitae tellus. Sed et est vel diam accumsan malesuada. Nulla elementum justo ut urna. Aliquam scelerisque semper odio. Duis blandit.

Can A Dog Really Catch A Fox?

Lorem ipsum dolor sit amet, consectetuer adipiscing elit. Phasellus vitae enim. Fusce a quam. Aenean fringilla dictum nulla. Mauris sodales massa ac dui. Ut nunc tortor, sollicitudin at, porttitor quis, odio. Nullam vitae tellus. Sed et est vel diam accumsan malesuada. Nulla elementum justo ut urna. Aliquam scelerisque semper odio. Duis blandit.

Which color combination can you easily read?

Given that the more contrast between background color and ink color is best, choose colors that provide good contrast. Likewise, select typefaces that also work well with your color selection. A good test is to copy a color proof you make on a black-and-white copier. If the type is too fine or coarse for the colors, the copy will show this. If you cannot read it in black and white, color isn't going to help. Go back and change colors or type selection if there is not good readability.

Creative License

If you're designing a website, you'll want to use one or two of the four typefaces that web designers now prefer: Times Roman, Arial, Georgia, or Verdana. Using more obscure typefaces may result in different type being substituted, changing the look and feel of your design. Not all computers have every typeface, but all do have the four listed above.

Branding

An organization's *brand* is its reputation, its image within its market, and how it presents itself in printed or electronic form, which is affected by the type and images shown in its designs.

For designers, a brand is a system that includes typography, color, and guidelines for how the organization's logo or mark can be used.

Graphic Standards Manuals.

Role Models

Consistency is an important marketing word. Smart companies strive for consistency in everything they do. Consistency of design, message, of image, of service, of product quality—these all contribute to the company's success. A company concerned with their image makes sure everything they use to communicate with the public has the same look—from business cards, to stationery, brochures, fax cover sheets, ads, websites, and anything else they have their name upon.

The Starbucks logo and green color are part of every location.

Many people believe that a company's logo and its **brand** are one and the same, although they are not. A brand is the overall image of a company or product, while the logo is a single image or mark created to identify the company. The yellow and red Eastman Kodak Company "K" is its logo, not the company's brand or image.

Starbucks, for example, works hard to ensure that customers have the exact same type of experience in any Starbucks location in the world. The coffee shop interior may be slightly different, but the experience—the music playing overhead, the available seats and tables, the smiling barista, the hot coffee served in seasonal Starbucks cups—that remains the same.

Even beyond consistency is a design-centric culture, such as you'll find at Target stores. The red and white Target logo is ubiquitous, even strong enough to stand on its own without a company name. But what makes Target a role model is its partnerships with designers and architects to give its customers exactly what they want. Design is woven throughout the whole organization.

Target has aligned its company brand with major consumer brand names, to further elevate its image and its bottom line. More recently, the company has moved to creating its own private labels to rival the major consumer brands—in food, Market Pantry is its low-end line while Archer Farms is more upscale, as suggested by the strength of the package design.

This creation of product lines, which is designed to appeal to different consumer market segments, underscores Target's intimate knowledge of its shoppers. By knowing its audience, the company can design a multitude of products and services it knows they will buy.

Just as a market is *segmented*, or broken down into sub-segments, so can product lines be created and new designs generated to reflect the product's positioning.

Market segmentation is the dividing of one group of customers into ever-narrower groups, based on factors such as income, spending habits, age, age of children, proximity of home to store, education level, and a million other factors.

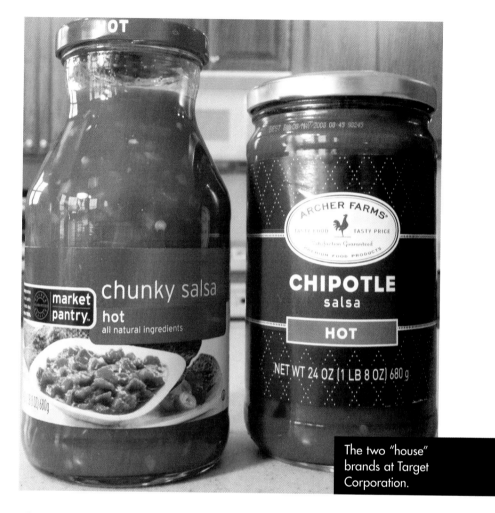

The two "house" brands at Target Corporation.

The Least You Need to Know

- Matching a typeface to a design's purpose or a company's brand image helps communicate the message visually, even without the text being read.

- How a company presents itself in printed form contributes to its brand image. A corporate identity manual can help a company ensure consistency in how its look and feel are presented.

- The rule of thumb is that once you own 1,000 different typefaces, you need to invest in type management software to better keep track of the many type families and to keep your computer running swiftly.

- How our eyes process visual information

- Strategies for creating visual hierarchy

- Adjusting type for emphasis

- Manipulating images to reflect their importance

- Finding examples to study

Creating Visual Hierarchy

Effective graphic design is guided by how our eyes see and process information on a page, whether printed or on a computer screen. Our eyes naturally gravitate to certain places on a page, but using principles of graphic design, we actually can draw the eyes' attention to other places, moving them from element to element.

That's the power of visual hierarchy, which is a graphic design principle that helps designers prioritize pieces of the design puzzle. Knowing what information or image is most important, down to which is least important, starts to define what will go into a design and where.

Using Visual Perception

Visual perception is our ability to interpret what our eyes see. Our brains and eyes work together to make sense of information from the environment.

Whether you realize it or not, we have a tendency to focus first on the center of an image. In English-speaking countries, we learn to read from top to bottom and left to right. So while we may unconsciously first look at the center of a page or image, we quickly move to the upper-left corner and scan across the page, much like we would if we were reading. That's our habit. Designers, however, like to influence the way a person views the image, pulling our attention away from those habitual spaces and moving them elsewhere.

Artists, photographers, and designers learn early in their studies about visually dividing a page into nine sections, using two invisible horizontal and vertical lines. When looking at an image or page, our eye is naturally drawn to the center section. So designers incorporate other design principles such as contrast, scale, proportion, and pattern to move the viewer's eye around a composition or design and outside of that center section.

Rule of Thirds

Understanding how the Rule of Thirds works is the first step to understanding visual perception. If you can imagine using lines and dividing a page into nine sections, you immediately know where the four strongest places to put information are—where each set of lines intersect!

The center of any page is where our eyes are drawn.

Using the Rule of Thirds will assist you when building well-balanced images and pages. But don't forget to "bend" this rule by using other design principles for variety in your work. You have to know the rule first before you push its limits—that's all part of good design.

Visual hierarchy is another key component to graphic design. It refers to a graphic designer's efforts to make design elements on a page appear to the viewer in the order of importance. Each element is ranked in terms of priority; then design principles are used to lead the reader's eye from the most important element to the next most important element, and so on. The higher on the hierarchy the information or design element is, the more prominent it will appear on the page.

> Space, often referred to by designers as **void,** as well as cropping and contrast, are among some of the designer's best tools.

Hierarchy can be ranked by position, size or scale, weight of type or color of image. Any one can be top-most in importance depending on design and placement.

Typography and imagery are the two basic design components to be used, with orientation, emphasis, dominance, proportion, scale, proximity, contrast, and visual weight as the tools.

What catches the eye first could be type, or an image, or a graphic element, all depending on where it is on the hierarchy.

Creating Visual Hierarchy

Altering the appearance of type, images, and graphic elements is the key to creating a visual hierarchy, so that all the information on a page does not appear to be of equal importance. In such cases, the eye does not know where to go and the reader becomes overwhelmed.

Typography

One way to create visual hierarchy is with typography, or type. Depending on the amount of space you have available for type, one strategy is to make the words bigger, bolder, with a heavier weight—where the letter appears darker. Such emphasis makes the word(s) more dominant on the page.

You can see how typography, image, and color vie for top position in the hierarchy of these vintage Dime Novels and a recent *The New York Times* front page.

The darker the contrast between paper and ink color, the more the type stands out, and the more important it is to the design's visual hierarchy.

Creative License

Magazines and newspapers frequently use pull-quotes—sometimes italicized quotes from a source that are excerpted and enlarged on the page—for emphasis, both visually and editorially. The key here is they look different from the original copy.

However, you may not always be blessed with plenty of room with which to work, and enlarging letters or words may not be possible. In many cases, though, you can still make the letters heavier or italicized without requiring more space.

In instances where you want the words, the type, to fade into the background, you can make them smaller by reducing the type size, by reducing the weight of the ink, and/or by using less contrasting colors—such as gray instead of black, for example.

As a result, the other elements on the page then become more dominant and more noticeable to the eye. Visual hierarchy is all about bringing emphasis where you want it, and de-emphasizing elements that are less important.

Notice how scale shifts our perception of reality with this image.

Images

Size and scale are the two ways to create visual hierarchy with images, whether they are photographic, illustrations, or technical line drawings.

The larger the size of an image, the more dominant it is on the page. Likewise, the size of the photo or illustration relative to its normal size can also be eye-catching. For example, when a push-pin is enlarged, or a ladybug, the result is increased attention to the normally small item. Depending on the type of piece you are designing, charts and graphs also may be appropriate as a visual element.

Charts and graphs can convey information and visually enhance a design.

The Least You Need to Know

- Visual perception is how our eyes and brain process information. Our eyes naturally gravitate to certain places on a page, such as the center, but by using graphic design tools, we can lead the eyes around the page.

- The Rule of Thirds is a design concept that divides a page into nine squares using four intersecting lines. The places our eyes move to first are where the lines intersect.

- The order in which eyes notice certain graphic elements is a result of visual hierarchy—a principle that helps designers make the most important elements the most eye-catching, the second-most important elements slightly less so, and so on. The result is that a design's components are revealed in their order of importance.

- Making typography or images larger is one strategy for increasing their importance and position in the visual hierarchy. Changing the normal scale of an image is another.

PART 3

From Black-and-White to Color

Color plays a big role in any design, so you need to choose carefully. In this section, we give you some pointers to help you wade through all the shades and hues to find the ones that best fit your piece. In addition to simply choosing a color or two, we also show you how to use color to catch the reader's eye and make an impact. Because color can come from many sources, including the paper your design is printed on, we offer ideas for making your design even more color-rich. Finally, you learn about reproducing your design on several types of equipment.

IN THIS CHAPTER

- Balancing impact with budget

- Following corporate rules

- Matching color scale with output

- Low-cost sources of inspiration

CHAPTER 8

Color Choice

In design, color refers to many things. Color has to do with the overall feel of your piece, such as warm reds and browns, or cooler blues and greens. Depending on who you are designing for, the color of your company's logo or the color theme of an event also plays a part in determining which other colors will complement it.

Perhaps most important, though, the number of colors you can afford to pay a printer to reproduce should be the starting point for determining how and where you will incorporate color into your design. While it is true that the more color you use in design, the higher the impact, it is also true that the more color you use, the higher the cost. You need to balance your budget with selective use of color to get the best results.

Color Theory

The way artists and designers use color today goes directly back to the theory developed in 1919 by Johannes Itten, a professor at the Bauhaus school in Weimer, Germany. His study of the psychological effect color has on us revolutionized the way color was used and is still used today. He began by arranging color according to seasons, a method still employed by the cosmetic and fashion industry today.

The color wheel in Chapter 3 shows the primary, secondary, and tertiary colors. In this chapter, we're going to talk more about how the colors work together. Harmony in color is that which is pleasing to the viewer's eye. These colors work well together and create an inner sense of order and balance in the visual experience. When the visuals are not harmonious, they are perceived by the viewer as boring or chaotic and thus the viewer is not engaged. Not a good thing when you want the collateral you're designing to elicit an action.

Here are some ways to achieve color harmony:

- Use a color scheme based on analogous colors.

 Analogous colors are any three tertiary colors that are side-by-side on the color wheel, such as yellow-green, yellow, and yellow-orange.
- Use a color scheme based on complementary colors

 Complementary colors are any two tertiary colors which are directly opposite one another on the color wheel, such as yellow-green and red-violet.

Color context is another part of color theory. A color can be perceived differently based on the background color. The color red looks vibrant and larger with a black background but seems duller and smaller on a white background. And if you place a red-violet rectangle on top of a blue background and the same red-violet color on a purple background the red-violet color looks to be different. This is only perceived as being different because the red-blue rectangle is the same color for both the different backgrounds.

The last part of color theory has to do with value and hue. Value relates to the lightness or darkness of a color where hue is the term for the pure color itself. The primary colors of the color wheel consist of three hues—red, green, and blue—that can be used to create other hues found in the secondary and tertiary color spectrum.

Although zeroing in on the background colors you'll use in your design is an important choice, your first step should always be to complete your design in black-and-white.

It might sound counter-intuitive, but unless your design can be reproduced on a black-and-white copier, or run through a fax machine, and still reveal everything you placed on the page, it is not ready for color. Color adds subtle tones and hues that black-and-white office equipment may or may not pick up. A dark image may turn out as a black square when faxed, or a logo with colors of similar value may appear to be one color instead of two. Be sure that your concept is effective even without color. Once it is, then you can go on to the second step, which is to go back in and add it.

Color images don't always reproduce as well in black-and-white.

Budget

We may sound like a broken record at this point, but the two most important factors that shape your designs are your audience and your budget. Your audience determines how you should communicate with them, and your budget sets any limitations on that design.

If you're designing for electronic distribution, budget is not an issue, because you can create and disseminate your designs without the added cost of a printer to consider.

However, when designing printed pieces, the size of your budget will determine whether you have the money to create a piece that is printed using *one-color, two-colors, four-colors,* or four-colors with fancy extras like embossing or a varnish.

The more colors you print, the higher the printing cost. While adding more color does not automatically double or triple the cost of printing, the price is incrementally increased. You can expect to pay 30 to 60 percent more for each color added. This is only an estimate; always get more accurate pricing from your printer directly.

See the difference adding more color makes.

Four-color printing is the equivalent of printing in full color, to get photographic quality. Less than four-color printing means that you will specify each color. The most common ink color in **one-color** printing is black. In **two-color**, the designer usually chooses another color, such as red or blue, and black.

The quantity of pieces you need also will affect your total printing cost, which we talk about more in Chapter 9. For now, just understand that while your piece might look best in full color, you may be forced to scale back to one or two colors depending on the funds you have available.

Personal Preference

If your company has provided you with a corporate identity manual, refer to that guide for instructions regarding which colors are required or preferred in materials the company creates. You may learn that teal blue always must be the dominant color, or that you may never, ever, under any circumstances, use orange. Some corporate identity rules seem to make no sense, but they do ensure consistency of image, which is important.

Once you understand your limitations, if any, regarding color selection, your next factor is what colors make sense for the message of your designed piece. That is, are there colors that often are associated with the information you're presenting?

For example, if you're announcing a sale on hot tubs, shades of blue would make sense to suggest water. If you're reporting on funds raised to support your local arboretum, green and brown (for trees) could be the obvious choice. An invitation to a winter family reunion in Colorado might suggest tones of white and gray, for snow. This is not to say that you must use the colors generally associated with the product or service you're dealing with, just that this is a starting point for your decision-making.

Your final consideration is your own personal preference. Most graphic designers come to recognize that they have their own favorites. Marj's recent favs are PMS 201, PMS 321, and PMS 583. Recognize, too, that your current color choices change over time.

© Ashley Rio

Some colors typically are associated with certain products or themes.

Design on the Cheap

If you don't have the money to invest in your own Pantone Matching System (PMS) guide, which can be pricey, turn to paint and scrapbooking stores in your area for paint chips (free) and ideas for which colors complement each other best. Scrapbook paper can suggest graphic elements and color combinations, too.

Personal preferences are fine, as long as you recognize them as such, and try to infuse other colors where appropriate. Don't limit yourself to those colors. Try to break those habits whenever you can and give different shades a try. You may find a whole new set of favorites.

Paint chips and scrapbook paper can be very inspiring, and cheap.

The **RGB** color scale is based on the red-green-blue scale, developed for use with televisions. All the colors are derivatives of those three colors. The **CMYK** scale used in digital output is based on the four colors used in the process: cyan, magenta, yellow, and black.

Print Versus Web Colors

When you start to design in color, keep in mind that how your computer monitor is calibrated will affect how the colors appear to you onscreen. This is important especially when designing electronically—a monitor that does not reflect the shade everyone else in the world is seeing can interfere with a company's brand image by causing you to choose colors that are slightly off.

Likewise, designing the perfect piece onscreen can be frustrating when the offset output does not come close to replicating the colors you saw on your monitor.

These differences are likely the result of using the wrong color scale. There are three main ones:

- Pantone Matching System (PMS)—used for ink
- *RGB* scale—used when looking at color on a monitor
- *CMYK* scale—used with digital printer output

The color scale you're working with needs to be in sync with your intended output in order to avoid color disparities. If you're designing a web page or online banner ad, make sure you're using the RGB color scale to define colors. And if you're designing a piece that will be printed, everything should be defined in CMYK. The PMS system should be used to define spot colors such as corporate colors.

Creative License

If you try to use the beautiful colors from your website as the basis for designing matching stationery and business cards, don't count on exactly matching the PMS color chips your printer offers to the RGB shades on your computer screen. You'll come close, but it will be hard to match exactly.

Corporate Colors

Existing organizations most likely will have selected one, two, or three colors as their official corporate colors. These are colors that perhaps exemplify their culture, their image, their industry, or their future direction. And they are an important consideration because they will probably need to appear somewhere on each piece you design.

Working with Corporate Colors

The existence of corporate colors does not mean you will necessarily be forbidden from using other colors, but that you may want to choose from similarly hued colors.

If your company uses a lot of jewel tones (ruby, emerald, or sapphire) in its marketing materials, you will probably want to select other vibrant shades in your pieces. Likewise, if your organization leans more on pastel shades, your designs would be jarring if you suddenly began incorporating richer colors.

Selecting New Corporate Colors

Should you have the luxury of choosing new corporate colors, perhaps because your company is redesigning its logo, changing its name, merging with another company, or going through a corporate overhaul, then your options certainly will be broader.

That is not to say that they are wide open, however. Choosing corporate colors often comes down to the color preferences of the key decision-maker. Sure, he or she may consult branding strategists or review competitor colors in making the selection, but because there is no hard and fast rule about the best colors for your company, it eventually will be a personal choice.

Creative License

A word of caution about corporate product names and use of specific colors. The culture and image of the company should certainly be taken into consideration, both in the United States and abroad. For example, going with a color that is associated with death in another culture might hamper overseas growth. The color red means danger in Europe, good luck and prosperity in Asia, and mourning in South Africa. So do your research about the culture as well as the competition.

The Least You Need to Know

- The more color you use, the greater the impact your design can have, but the higher the output cost. Determine your printing budget at the start to avoid disappointment later.

- Design first in black-and-white, to ensure your piece can reproduce well when copied or faxed. Then add color.

- When designing for print, web, and digital output, make sure you use the right color scale for your device, or your shades will be slightly off.

- Paint stores, scrapbook stores, and magazines are great sources of color inspiration.

CHAPTER 9

Paper Selection

To some designers, paper is simply one medium on which they can produce their designs. But to smart designers, paper provides another layer of texture, pattern, and color that can make a layout a true standout.

With so many varieties to choose from, however, zeroing in on the perfect weight, type, and color of paper can be vexing. While your personal preference plays a big role in determining which paper is best for your project, there are some design guidelines that can help, too.

Weights

A paper's weight refers to how thick a sheet is, measured in pounds per ream (500 sheets of paper). The higher the number, the heavier the paper.

The three basic paper weights are as follows:

- Writing (Bond or Duplicator): 20–32 lbs
- Text: 60–110 lbs
- Cover: 60–120 lb

Before you begin evaluating paper weights, you first need to decide whether you'll be printing your design in-house, or whether you have the budget to let a commercial printing house handle it. If you're doing all the production in-house, your paper choices will be limited to those that can be fed through office equipment without jamming or damaging the machine. Generally, that is not much higher than 24-pound weight, with little or no texture to interfere with how the ink adheres to the page.

If you'll be having a commercial printer producing your design, you have far more options available, starting with text or cover weight.

Writing

Writing paper is probably the most versatile weight of paper; it is perfect for an array of everyday documents. Most office paper is either 20- or 24-pound weight, which can be used in everything from printers to fax machines to copiers. But, many mid- to large-size copies today can handle 28# and oversized stock, even if one needs to hand-feed or manually load the machine.

Text

The two major paper decisions designers need to make are whether they want a *coated* or *uncoated* finish, and writing, text, or cover weight.

Text-weight papers range from lighter-weight varieties that can be used in copiers and printers, to 110-lb weight, which might be used as a section header in a binder, for example.

Cover

Most commonly used for brochures, folders, and soft-bound reports, cover-weight papers are thicker and more durable, and generally cannot be run through office printers without some complication at the upper ends. Sixty to 80-pound cover-weight paper can be used in most copiers, but above 80 pounds it is too thick.

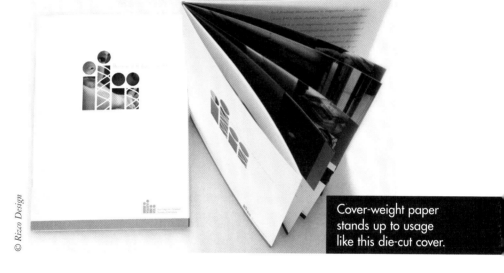

© *Rizco Design*

Cover-weight paper stands up to usage like this die-cut cover.

Texture

Paper's texture has to do with the actual feel of the paper, due to the content used to form the paper. The content of the paper, especially fibers in recycled products, adds greatly to a project and also makes a statement. The texture of a paper can influence perceptions, and designers love getting that extra boost for their designs.

Laid

When the pulp is laid out over fine wire, it creates a fine screen pattern that you can see and feel. The horizontal lines are often thinner and lighter in their impressions, whereas the vertical lines have deeper and thicker marks. The added texture of these ridges

enhances the overall impact of your design without adding color, although you also can buy laid papers in many different colors and patterns.

Rather than flat, plain paper, laid styles are very popular for added pop, as you can see the wire marks and also the various colored fibers used in making this paper.

Linen

Another texture that looks somewhat like vertical stripes is linen. The linen texture is created with a different screen used to press the pulp into a sheet. The stripes are tactile and resemble the "slubs" found in threads made of paper. However, they are not created with color.

Linen is often used when a formal look is desired. But these "lines" in the paper will also add dimension to your piece, so keep this in mind when creating simple, elegant designs.

Patterns

However, some people don't necessarily care as much about the feel of the paper as they do the appearance, which is why they opt for patterned papers. Patterns, such as stripes, dots, herringbone, plaid, and other background shapes, add dimension to designs, typically with a tone-on-tone effect. Designers keep this in mind when creating collaterals because patterned paper competes visually with complex designs—not in a good way.

Patterned papers actually were created by paper manufacturers to give designers the look of textured papers without the problems that high-content rag papers can have. Namely, inkjet ink or toner doesn't always adhere as well to textured papers, or you may see capillary action, where the ink spreads beyond the letters, making the document look sloppy. If you work hard to design a complex piece that uses a lot of color and graphics, you might want to consider a plain paper and let it be a more neutral backdrop to the beautiful design.

Design on the Cheap

While you may have specified a certain coated white paper for the brochure you just designed, ask your printer whether they have any comparable leftovers you might be able to use at a discount.

Environmental Choices

With increasing emphasis on making smart environmental choices to lower our impact on the earth, many graphic designers are opting to work with environmentally friendly papers.

Recycled Papers

The most common choice is recycled paper, which has been around for decades. The key in choosing from among the many recycled varieties is to look at the percentage of "post-consumer waste" it incorporates. The higher the percentage, the greater the good you know you're doing.

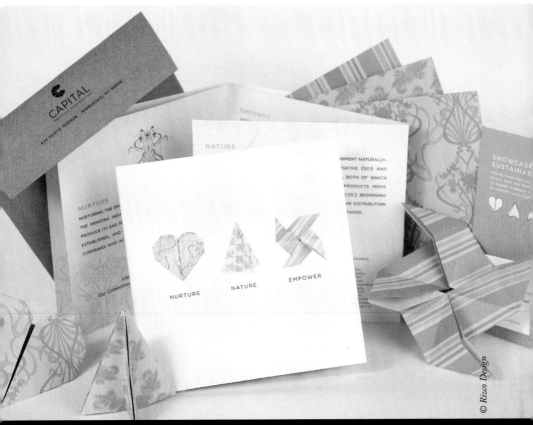

© Rizco Design

This environmentally conscious printing company announced their sustainability initiatives to its clients.

Certifications to Look For

To be sure that you're working with environmental suppliers, you also can choose a Forest Stewardship Council (FSC) certified printer. FSC works to support sustainable forestry worldwide. FSC certification is a type of verification ensuring that printers and paper mills have committed to purchasing alternative fuels to reduce their impact on the environment.

Creative License

In addition to using recycled papers, you also can use recycled or soy-based inks, for a greener project. Ask your printer about the cost to use such inks—you may find the cost negligible.

Where to Buy

When starting out, the best place to ask about available papers is local commercial printers. They can tell you which paper companies have representatives in your area.

Paper Representatives

Paper company representatives can be a wealth of information about possible paper choices for your projects, as well as keeping you updated about new product offerings. Companies like International Paper, Dolphin Paper, and Xpedx are among the nation's largest. Check online to find paper distributors and their representatives in your area.

Retail Paper Outlets

Some paper companies set up local retail outlets so that graphic designers can stop in and pick up low quantities of their paper for smaller jobs. Do a Google search for local paper stores to learn whether any are in your area.

The Least You Need to Know

- Paper comes in writing, text, and cover weights, with writing weight being copier-paper grade and cover weight being heavy, brochure-cover weight. Text weight covers a wide range in between.

- Textured papers are actually formed by wood pulp being laid out over wire to form shapes in the paper—laid and linen are the two major types. Patterns, on the other hand, are printed onto the paper using tone-on-tone colors and shapes.

- With such a wide variety of environmentally friendly papers on the market, it's important to look for those with a high percentage of post-consumer waste.

- Printers can be FSC-certified, meaning they have made a commitment to reduce their impact on the earth.

- In-house versus outsourcing

- Inkjet and toner-based printers

- Pros and cons of offset printing

- Up-and-coming digital devices

10

Production Needs

Once you've designed a piece that needs to be printed, perhaps a flyer or postcard, report or proposal, it's time to decide exactly what type of printing technology you will use. You have several options, but your audience and budget should drive your ultimate choice.

If your budget is minimal, you may be limited to using printing devices you have at your disposal, either at work, home, or school, or through friends and colleagues. And they can work just fine. But if you have money available to cover the cost of outside printing, such as at a commercial printer, you'll want to compare the quality and cost of the various output alternatives.

In-House

Although you may be under the impression that offset or digital printing is always better than the output provided by your color printer, there are many advantages of using a printer or copier close at hand.

Desktop Printer

Sending your design to a desktop printer can produce a product that is of high quality, low cost, has the flexibility to print as few as one piece, and can be done almost immediately.

Laser-printing technology is considered superior to inkjet, because the lines and letters produced by a laser printer are crisper and cleaner than that of an ink jet, which is based on a dot pattern.

Whether you're printing on a laser or inkjet printer, if you plan on doing large quantities of printouts, compare the cost of a single printout with the cost to photocopy to see which is cheaper.

Copier

Some multifunction units, such as combined printer/copier/scanners, can be a great way to gain color printing capabilities without adding several new pieces of equipment to your office.

In printing terms, a **bleed** means that the ink is printed up to the very edge of the paper, so that there is no border around it.

If a multifunction unit is what you have, you can choose to either print directly to it, or print out a single design and then reproduce it on the copier. That's what some designers working with in-house equipment do—print and then copy.

In the industry, printers and copiers generally fall into one of two categories: office and production. Office printers and copiers often use solid-ink and dry-ink technology, whereas production printers use dry-ink toner. Both are effective, but cost is a factor here. The smaller the "box" or size of machine, the more expensive the per-page rate.

However, not all design projects are conducive to being produced on a printer with a maximum paper size of 8.5×11 inches. Some projects require larger paper, or thicker paper, or ink *bleeds* off the page, which oftentimes the office copiers cannot accommodate, but a large copy center or commercial-grade printer can.

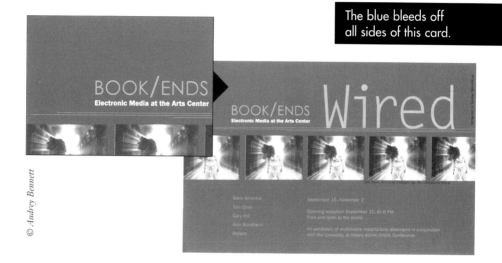

The blue bleeds off all sides of this card.

© Audrey Bennett

Outsourcing

Some design projects are destined to be outsourced to printing professionals, either because they are of sufficient quantity or of sufficient importance, to require outside help.

Offset

Offset printing involves converting your design to metal plates, which are affixed to a printing press and then run through to connect ink to the paper at the specified locations. It is the traditional process that has been used for centuries, with improvements and modifications along the way, of course.

The advantages of offset printing are that colors can be matched almost exactly, and it's possible to add additional treatments, such as a varnish or embossing, over top of the ink. If you're planning on printing en masse, it's also the most economical.

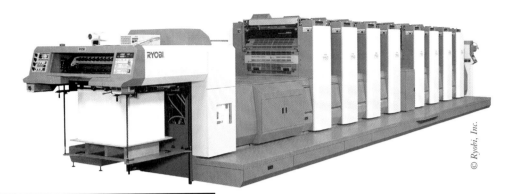

© *Ryobi, Inc.*

Ryobi is a major commercial printing manufacturer.

The disadvantages of offset are that it can take days or weeks for your printing job to be run, and then additional days for it to dry and be cut down, folded, glued, or whatever else needs to be done to form it into your desired shape.

For example, a multipage brochure starts out as several sheets of large paper. After the print has dried, the paper is cut, stitched, or stapled, and any pockets or folder edges glued down.

When you're using an offset printer, you'll want to allow at least two to three weeks for a large job to be completed.

Another instance where you'd want to use offset printing is when you need *spot color* on your design.

Where offset printing is perfect for large quantities, digital printing is often best for smaller quantity projects, generally under 2,000 pieces.

The term **spot color** in the design and printing industry refers to using one Pantone color ink or a single run (meaning one color printed.)

In the office world, the term spot color refers to a small section of a copied piece where a color has been added. The color is not applied to the entire piece, but just to that one area on the page.

The office use of the term in the design and printing world equates to a two-color printing job.

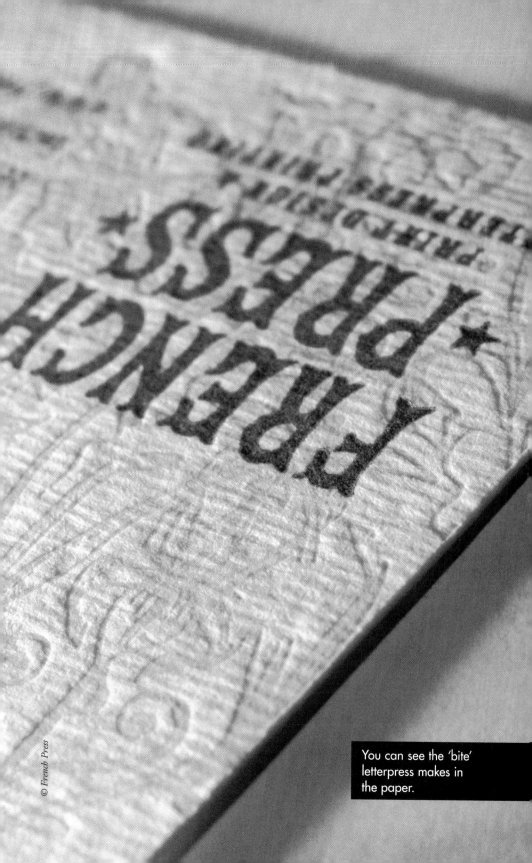

You can see the 'bite' letterpress makes in the paper.

One additional step you'll need to be prepared for with offset printing jobs is the press check, where you are on-site at the printer's office to check over your design as it is being produced. The purpose of a press check is to confirm that everything you designed is being reproduced as you expected, down to the last detail.

Design on the Cheap

Although the setup cost of offset printing can sound steep, once the presses are running, the cost per piece falls, the more you print. If you're printing in quantities of 10,000s or 100,000s, the cost-per-unit of offset printing will be hard to beat.

The spot color here is PMS 562.

Creative License

Try to lump as many printing projects together at once, called a "gang run," to save money. If you're printing a brochure, have stationery or business cards run at the same time, or postcards added on. Once the press has been set up with your corporate colors, the added cost to run extra projects will be much lower than printing them separately.

A key tool in the press check is the loupe, which is a small lens you look through to see the printing quality up close. With a loupe you can spot:

- Any places where colors don't line up expect, also called the registration
- Scratches on the plate that appear as marks on the paper
- Bits of dust and small particles that are specks or circles in the printing
- Color shift, when the ink color you specified is slightly off

As you're checking over the press proof, which is what the printer gives you to look at, you circle any problem areas for the print pros to correct. They'll go to work, run another proof, and bring it out for you to inspect again. When you're happy that the proof matches the dummy you approved, you sign the proof and your piece is printed.

As the graphic designer, it is your responsibility to ensure that the printed piece you designed matches the design your boss or client approved. The only way to do that is to work with the printer, as well as any finishing houses like binderies or embossers, every step of the way.

Digital

Where offset printers use metal plates and liquid ink, digital printers use neither: the process is electronic, with your design reproduced using dry ink (toner) directly onto the paper you've selected.

And instead of sending your work out to a commercial printer, where a sheet of paper can pass through a press up to four times, a digital plotter or printer only requires one pass through, much like a copier.

The process itself is faster, because you can go directly from your computer into production, and you don't have to wait for wet ink to dry. Digital printing is nearly instantaneous, which is why it has caught on in recent years, becoming more popular as prices have come down and the pace of business has quickened.

If your project calls for full-color photography, which then requires four-color printing, digital printing makes a low-quantity color piece affordable. Where you might not be able to afford to print 100 copies of a capabilities brochure or annual report for a nonprofit on an offset press, the cost to produce it on a digital printer will be a fraction of the offset cost.

The advantages of digital printing are its speed and cost for low quantities of a piece. However, at much higher quantities, it is not as economical a choice.

You need to remember that the color output of a digital printer is slightly different from the colors on an offset press. That is due to the differing color scales we talked about in Chapter 8. Offset printing presses use the PMS system to match colors, while digital printers use the CMYK scale. And while a pressman operating an offset press can tweak the colors to match what you were expecting, the toner used by digital printers cannot.

Design on the Cheap

The more common the paper you select for your printing projects, the less expensive it will be in production. Ask your printer what stock he or she may have on hand that is similar to the paper you initially specified. If they don't have to special-order it, you can save some big bucks.

You'll save more if your piece uses a white sheet. Also ask the printer what they have as a "house sheet" and use this to save time as well as money.

The Least You Need to Know

- Many designs can be produced using printers and copiers you already have access to. If you don't have the budget or the time, using in-house office equipment is a decent option.

- If your design is too big to be printed onto a standard office-size paper, you should ask both offset and digital printing companies to bid on the job.

- Offset printing presses often can match colors more closely than digital printers can, by adding or subtracting inks while the project is being printed. Digital printing does not have that flexibility.

- Smaller-quantity jobs, under 2,000 units, will typically be less expensive if printed by a digital printing company.

- Offset printing is generally the better choice for large-quantity jobs, 10,000 units or more, because the cost-per-unit declines as the volume increases.

Adding Pictures

Photographs and illustrations make your design come alive, unifying the colors and typefaces you've already chosen. When will a photo work better than an illustration, and vice versa? In this part, you learn all about photographs—hiring a photographer to shoot what you need, or skimming existing photos in stock photo galleries to finding the perfect image. Or if you know an illustration will capture the mood you're really going for, you'll get some tips for finding and hiring a professional illustrator.

IN THIS CHAPTER

CHAPTER 11

Choosing Types of Images

Graphic images, whether they are photographs, illustrations, charts, graphs, or line drawings, are an essential component of good design. Text alone on a page is much less effective than with some visual images.

That doesn't mean the image has to be the focal point of your design, but it does need to be taken into consideration. And you'll want to evaluate what type of image will best reflect the theme, style, tone, and message you're trying to convey in your design.

For example, if you're sending out a postcard announcing the opening of a new restaurant, you probably want a photo of the space, to entice recipients to check it out. If you're designing a media kit featuring a revolutionary new product, including some kind of image of the product itself is smart. Or if you're helping prepare a bid for a major government project, you may want to consider including plenty of charts and graphs to liven up the pages and make the case for your selection.

Whether a photograph or illustration will work best in your design depends on your audience, the type of piece you're designing, and how much money you have to spend. There is no one hard-and-fast rule about which to use.

Photographs

Photographs are perhaps the most frequently used image because they leave no doubt as to the subject matter. But beyond the obvious, they also can suggest mood and style, enhancing the overall reaction to your design.

Before you consider any photograph, you need to finalize your design so you know what kind of image you need—what the focal point is. Depending on the type of organization, event, or purpose of your design, the possible images that are appropriate will vary.

For example, if you're designing something for a restaurant, you'll need food shots. For an employee benefits brochure, you'll want pictures of people and activities. For a daycare center, children, toys, and educational activities would be smart choices.

Your design concept tells you what type of images you need. After you know what you need, the next decision to make is whether to purchase from stock photography and use keywords to find images or hire a photographer to take photos of specific people, places, and things.

Hiring a Photographer

As you evaluate whether photographs are the best supplement to your design, you also may want to consider whether you can take your own or whether you need to hire someone to take the photos for you.

Sure, if you're designing a high-end catalog, you probably want a professional photographer behind the lens to get the lighting just right for each product being featured. But if you need candid photos of your organization's recent event, photos you took yourself are almost expected—how many companies can afford to have a professional photographer at-the-ready?!

See how much nicer the photograph of the bottle is because of the controlled lighting provided by the professional photographer.

But your budget should be your guide here. Get the best images you can afford.

If budget is not a major issue, these are some major factors:

- The time available—Even if you could afford it, do you have enough time to send a photographer to the Caribbean for a beach scene?

- How you'll use it—Where will the image appear? Is it the cornerstone of a new ad campaign, or a nice-to-have additional to an internal newsletter?

- Need—Is a photograph critical or would an illustration or stock photography work just as well?

In general, the more important the design project, the more you should budget for photography. Any time you need photos of products, executives, facilities, or other important elements of

your business's operations, it's best to rely on the skills of a professional photographer. They will probably turn out better than if you took them, and you can be assured that no one else will be using them. Using a professional photographer, like using professional designers, brings a level of craft and skill that is called upon for needs such as product "beauty" images, annual reports, and imagery for package designs. Most professional photographers have a "day" rate that is often based on the hours or days needed for the job. Other charges include an individual fee(s) for an assistant, a stylist, model(s), film processing, printing or digital correction and burning fees, and travel expenses.

You'll find that there are plenty of photographers to choose from if you look through your local Yellow Pages or marketing communications directory. So how do you know which is the best choice for your project?

First, ask for recommendations from colleagues in other organizations. Who have they used? Who do they recommend? Tell them a little about the type of piece you're developing and the image you want to project. What type of photos do you need—product images, portraits, outdoor scenes? Sharing this type of information helps others point you in the direction of a photographer who specializes in that type of work.

After you have a list of candidates, ask to see their portfolios. Set an appointment to visit with each one; ask about the types of work they prefer, the kinds of organizations they most frequently work with, and their rates. See who you click with during interviews.

After you hire the photographer and set a date for the work to be done, you'll need to prepare to direct the photographer in order to get the images you need for your design. Photographers know how to light a scene and they have great composition sense. They can be great collaborators for extra image ideas, your job as art director is be there to look at what they're shooting and adjust accordingly so that it fits your design.

When directing photographers, the first thing to remember is to be clear with your requests before the day of the shoot. If you want a tight head shot with moody lighting, tell the photographer.

It's always good to ask a photographer to take several variations at each scene set up. It's good to get three shot variations:

- An overall, wide shot to give context to your images
- Tight shots—faces, products, or action
- Detail shots—close ups showing parts, texture, or patterns

Talk about all these needs before you start the shoot. After you've discussed them, step back and let the photographer do his job and don't micromanage him once the photo shoot begins. Do make sure you like the shots the photographer is getting; photographers are often eager to show you the shots, so everyone gets what they need.

Using Stock Images

In instances where you just need a generic image, however, such as kids playing, a couple walking on the beach, or an image of the front of the New York Stock Exchange, stock images can be an even better option.

Stock images are immediately available, which is a big plus when you're on deadline, and they are much less expensive than paying a photographer to fly somewhere to take original photos. Unless you need close-ups of a company asset, take a look at the huge variety of stock images on the market today.

Stock images, or stock photography, are photographs taken by photographers that can be licensed for use in your designs. You pay a usage fee, often based on how large it will be in final form and how many people will potentially see it, and in return, you are granted permission for one-time use.

The advantages of stock images are many, besides immediate access:

- You can download a watermarked, low-resolution image to lay into place for your client to review and approve before buying.
- Depending on which company you deal with, the cost can be extremely reasonable.

- The quality generally is much better than if you took the photo yourself.

The major downside of stock photography is simply its accessibility. That is, the photo(s) you select may be used by other designers for a variety of different projects. It can be disconcerting to see the image you thought was perfect for your client pop up on an ad for a totally different product. And your client may not be too happy, either.

To be safe, look at the information on the website alongside each stock photo, to find out how popular it is, or how many times it has been purchased, before you decide to use it. You may prefer to opt for a similar, but less popular, image to avoid such situations.

Just some of the types of images available as stock photography.

Reverse Type

In addition to legitimate stock photo houses, such as iStockphoto (www.istockphoto.com) and Getty Images (www.gettyimages.com), some amateur designers think that Google Images is a great source of free stock photos. Not so. In most cases, you do not have permission to use images found on Google. You could be charged with copyright violation.

Hand-Drawn Illustrations

When deciding between photography and illustration, the biggest factor should be the style of your designed piece. If you're promoting a product, photographs are generally preferred as a means of showing potential customers what it looks like. But if you're promoting a service, illustrations and artwork seem to be equally useful. It all depends on the look and feel of your overall design.

Another consideration is whether photography alone can capture the level of detail you need in the image. This is common in more technical environments. In some instances, you may need to combine a photograph and illustration to help viewers see specific parts, such as a switch in a copier, or where the battery compartment is on a toy. And in others, an illustration alone will best show how a process operates, or how a piece of furniture goes together, for example.

Before you decide, it might help to review the many styles of illustration available. The variety of techniques and media available is staggering, so you may want to start by selecting a technique, and then zero in on illustrators who use that technique or on a set of stock illustrations to use.

Hiring an Illustrator

To find possible illustrators to create the images you need, turn to some of the following sources to get started:

- Annual books of award-winning illustrations
- Colleagues, to ask for referrals
- Websites showing illustrators' works
- The Yellow Pages

- Local artist associations
- Ad agencies, which may use illustrators frequently

When you've compiled a list of at least three illustrators, ask to see their *portfolios*.

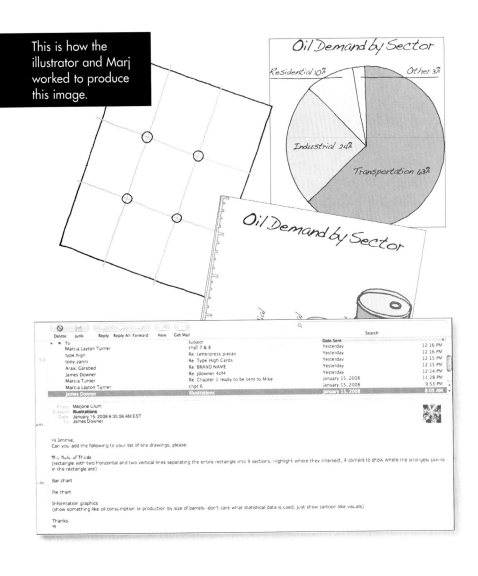

This is how the illustrator and Marj worked to produce this image.

A sampling of stock illustrations available.

As you review illustrators' portfolios, pay attention to their style, the subject matter they seem most comfortable drawing or painting, and the breadth of techniques they use. Do you like most of their samples? Are any similar to the look you're after? Unless the answer is yes, keep looking elsewhere.

Using Stock Drawings

As with stock photographs, many professional illustrators make works available to license by graphic designers and companies. The drawings and paintings are already created, and you, as the designer, have the option to license it for your particular project, for a fee.

Usage rights are generally priced by size, with larger sizes costing more to use.

In some instances you may be able to find out what other types of companies have already used the illustration, and you may even be able to negotiate exclusivity, for an added fee. But if the illustration is that important an element in your design, having an original piece of art created might be the safer way to go (if your budget permits).

Altering Images

If you're having trouble finding an image that exactly meets your needs, another option is to consider altering a photo or illustration. If you like the subject of an image but it doesn't fit the look, style, or color scheme of your design, you may be able to use special effects to manipulate the image.

Usage Limitations

The one caveat, however, is that some images do not permit any alterations. Some do, but not all.

As you're reviewing possible photos or illustrations, pay careful attention to any restrictions on its usage, such as whether it can be altered in any way. If you can't, then don't buy it for that purpose.

Ch-Ch-Changes

If you can get permission to alter the image, or it's not an issue because you own the image—photo or illustration—you'll want to open it using your image manipulation software, such as Photoshop. From within Photoshop you'll be able to make a number of changes:

- Use a filter for a more graphic appearance
- Crop the image to focus on one section
- Use several sections of the image in a new way
- Convert it from color to black-and-white
- Give it an all-over color wash
- Use it as part of a border
- Take a portion of the image out

The image you end up with should provide interest and information to supplement the copy in your design.

Whatever you do, save each variation file with a new name or add a number to the file name so you don't permanently alter your original.

The Least You Need to Know

- To be sure that no other person or organization will be able to use the same photo or illustration, you should hire a photographer or illustrator, and buy all rights to the work he or she does for you.

- Stock photos and illustrations are an excellent way to gain access to quality images at an affordable price. The downside is that everyone else has the same access, so you may see your favorite image on other designs.

- When an image is close to being perfect, but not quite, consider altering the image to change the color, crop it, remove an element, or make a number of other modifications.

- Make sure you have permission to make alterations before you undertake them, however. Some stock images forbid alterations.

Photography

Chances are good that the photo(s) you've chosen to feature in your design is not perfect. Yes, it may show the person who is the subject of the article, or the facility mentioned on page 3 of the proposal, but rarely is it possible to download an electronic image and place it neatly into your design and be done. It just doesn't happen.

But that is okay. There is so much more that can be done to improve a photo's quality, shape, and appearance. You don't have to settle for a low-resolution image when you can enhance it on your computer. You don't need to settle for a horizontal shot when you need a vertical one. You can crop it.

Once you understand some of the basic rules regarding photographs—applying the elements and principles of design, rule of thirds, and other techniques we've discussed in earlier chapters—your designs will be even more impressive.

But even when the photos you've been given aren't ideal, you can use special effects and image manipulation tools make to change the light balance, color, and overall impression of photos, as well as removing distracting subjects.

Subject

The best photo for your design supports the copy presented and matches the overall style and tone of your piece. In other words, if you're trying to evoke a relaxing theme and feel, the photo should match that idea. Or if you're trying to position your company's newest product as the latest and greatest, then the photo of the product should be awe-inspiring.

People, Places, and Things

Sometimes your need will be for a straight photo of a person, such as the leader of your organization or a star volunteer; of a place, such as a little-known spa in the desert or a sun-drenched bedroom; or a thing, such as a Maine lobster or a kiss.

Easily found online at many stock photo sites.

Depending on your design, the photo can be clear and realistic, or stylized to enhance some aspect of it. For example, you could convert a color photo of your child to black-and-white, but then add a touch of color on her cheeks.

Sometimes you don't have a choice in the image you're given to use, which is where your knowledge of cropping, color correction, and manipulation software can help. If your design depends on background images and other design complexities, knowing how to remove a portion from a photo might be the solution.

Evocative

Even if you don't need a specific subject in your photo, you may need an image to serve as background decoration—to set a mood or evoke an emotion. Depending on your audience and whether the need is to merely report on a situation, create an appeal for support of a cause, or show a product or process, photos are used both overtly and subtly to accomplish this. In today's fast paced world, photos are good tools for designers to deliver the visual message.

Other ways photography can be evocative is through the use of dramatic lighting, unusual subject matter, and photo-manipulation techniques used to alter an image or create collages to reflect a theme.

A different point of view adds dimension to the image.

For example, a black-and-white photo of a crumbling building can be about a blighted neighborhood, increasing crime, or the importance of preserving historic buildings, depending on the purpose of what you are designing. The specific building itself is not important—but the feelings the photo evokes can be powerful.

Reverse Type

Photos shot straight on, rather than from an angle or unusual perspective, are generally boring. If you're taking photographs, try capturing them on a diagonal, from below, or from above, as a way to make it more visually interesting.

Same image two ways

Sizing

Once you've settled on the subject in your photo, your next issue is sizing it. In a best-case scenario, you'll find an image that matches the space you have to fill. That is, if you have a horizontal space, you'll find a horizontally oriented image, and if you need a vertically oriented image, you'll find that, too. But more often than not, the perfect image is the opposite orientation than what you need.

Fear not. You can resize it in many cases. Not in all, but in many.

Avoiding Distortion

Sizing your photo—meaning that you will change the size of it to match the image space—is not hard as long as you keep the height and width proportional, to avoid distorting it.

How do you do that? Easy. When you begin altering the size of your photo in Photoshop, use the Image Size command under the "Image" menu item. In the dialog box that appears you see size controls. To size an image you want to keep proportions (height and width, or vertical and horizontal controls) linked. You know they're linked because of the "chain link" visual icon seen in the dialog. As long as the chain appears unbroken, your sizing will remain proportional. If you allow the height-to-width proportion to change, or the chain to appear "broken" or separated, you will end up stretching your photo and making it appear distorted.

Secrets of Good Resolution

Today, most photos are processed digitally, so we're going to assume any photos you're working with are electronic and not film-based.

Lighting, subject matter, and equipment used can affect the overall quality of images. Another, equally important factor that affects the quality of the photos in your design, is the *resolution*. Obtain and use images that have at least 300 dpi or better at size to appear on page. The higher the resolution, the better, you can always sample the image at a lower resolution if you have an image that was created or scanned at high resolution settings.

Today, the minimum resolution you need for anything to be printed is 300 dots-per-inch (dpi). Photos to be used online, on a website, or on an e-zine, should be 72 dpi, which is the standard.

A horizontal image can be used vertically through cropping and resizing.

Use the program's guidelines to check out how the cropped image will appear.

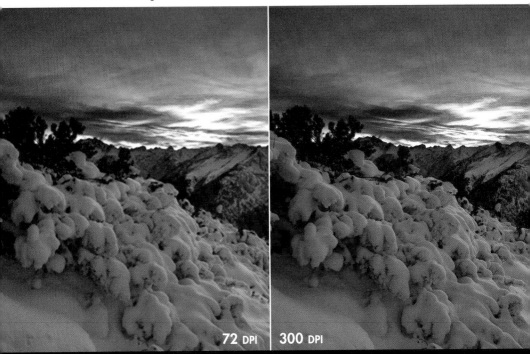

72 DPI | **300 DPI**

If images are not saved correctly, the image's resolution will be compromised.

If you have photos you want to use that are not the standard resolution, you may be able to modify them using image manipulation software like Photoshop. But if you start with a low-resolution image, there is only so much you can do to improve the resolution. Situations like this depend more on artist improvements that can be made with some of the filters available in Photoshop, but do not overuse these either—that can be the mark of a true amateur.

Resolution has to do with the density and clarity of the image itself, often specified in a 'dots per inch' or dpi measurement. The better the resolution, the crisper, clearer, and more vibrant the photo appears.

Many software manufacturers have tips and tutorials available to help with manipulating images. Just remember when purchasing stock imagery, buy the image with the orientation needed and the highest resolution needed for the use. If buying images for the web, the resolution can stay low, but for print needs, buy the highest resolution—you won't be sorry. Another tip if you're

taking images with a digital camera, go back and reread the camera's manual. Many folks don't take enough time to actually read a manufacturer's instructions but they often have great guides to help you learn how to get the most out of your camera.

When saving images, you'll want to save photographic images as JPEG files if you have the option, but drawn images and illustrations are better saved as TIFF files. JPEG and TIFF are the file extensions the computer looks for to know how to present them onscreen.

Cropping for Effect

You've probably heard of the concept of cropping in photography, which is really just cutting away parts of the photo that are of no use, so you can focus on the most important section.

Shift Focus

For example, you may have a photo of a lake scene with a sailboat in the foreground. If you're really only interested in the sailboat, you might want to crop the photo so that you can zero in on the boat, without being distracted by the water surrounding it. Remember, though, if the image that you want to show is very tiny, you won't be able to do too much because of the resolution. Even though the total photograph resolution is 300 dpi, the portion you want to use is a small fraction of the overall image. It already is at its best resolution. To crop and enlarge this portion alone will not be the same. It is somewhat like taking a perfectly baked and decorated cake slice and trying to share it with a group of people. While it is perfectly created, it is still only a slice and it can only go so far among a group of people. Perhaps selecting a different image is better.

Avoiding Mistakes

As with sizing, you'll want to be sure you don't change the proportion of the image as you're cutting away excess background. Use the cropping guidelines that photo processing software provides, to avoid altering the resolution or balance of the original image.

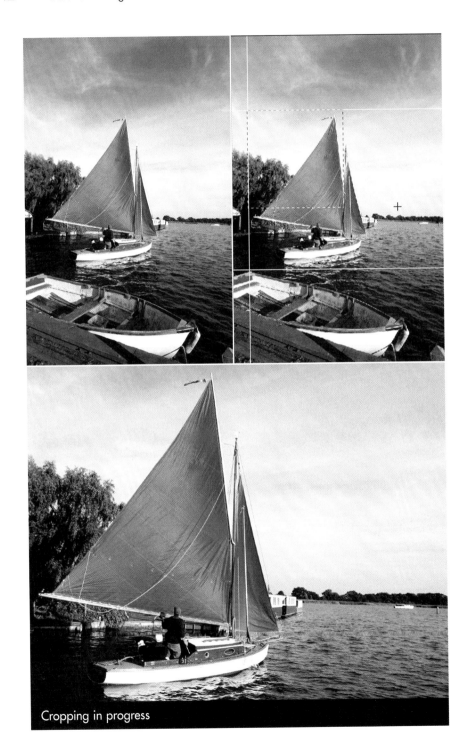

Cropping in progress

Using Filters and Effects

After you've selected and sized your photos, it's time to decide if you want to enhance or change their appearance using filters or other techniques before you put them into your design and start finalizing how the piece will be printed or shown onscreen.

For example, you can use selective color, so that parts of your photo are in four-color and other parts are in black-and-white. This can be particularly effective if you show a product in color against a black-and-white background. But there are multiple filter options. There are artistic filters that simulate brush strokes

Notice the use of selective color with the black-and-white has a very different effect.

and different media like watercolors and scratch boards, and other filters to distort and create textures—explore your photo-editing software and check out online tutorials and tips.

Creative License

If you make sure your photographer is shooting images in color, you'll have the flexibility to convert them to black-and-white, sepia, or other shades later. But, unfortunately, you can't convert black-and-white into color.

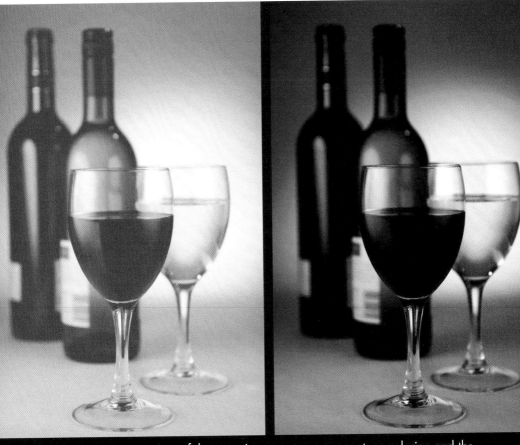

Here are two versions of the same image, one uses monotone coloring and the other uses duotones.

Monotones and Duotones

Color photos can be used in color or can be altered to scale back on the amount of color shown. The most common alteration is to a monotone, one color; or duotone, two colors.

Black-and-white and sepia (brown) images are monotone, while two-color images might use black-and-white and one additional color for emphasis, such as blue added to a photo of water.

Balance

One change you may need to make is to the balance of the photograph, or the amount of light exposure. Some photos may be underexposed, in which case they are too dark, and others may be overexposed and have much too light. Fortunately, you can do a fair amount of correcting using Photoshop.

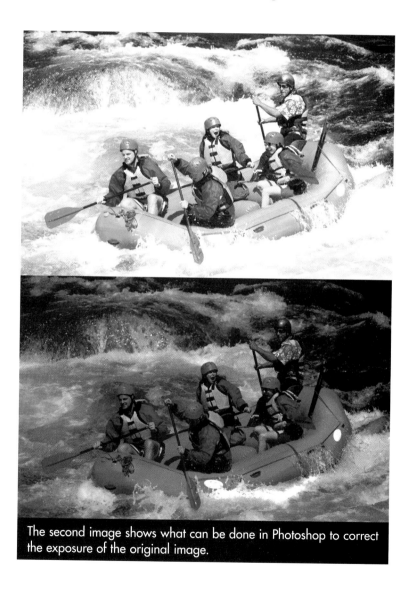

The second image shows what can be done in Photoshop to correct the exposure of the original image.

Filters and Special Effects

Within Photoshop and other image manipulation software packages, you have the ability to overlay filters that change the appearance of the photo, or to add special effects.

For example, you can make a standard photo look like a drawing or a watercolor image. You can overlay an oval-shaped filter that makes the center of the photo bright and the edges increasingly dark, bounded by a circle.

Special effects can be extremely useful when you have the perfect photo for your design but it doesn't match the theme you were going for. So using Photoshop, you can tweak the balance, add a filter, pull back on the color or add more, all to make the image better reflect the message in your design.

If you'd like more guidance in using Photoshop, take a look through *The Complete Idiot's Guide to Photoshop*, which goes into far more detail than we have space to here.

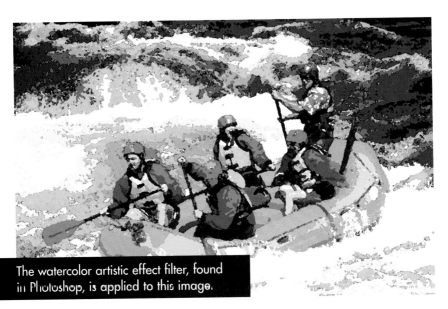

The watercolor artistic effect filter, found in Photoshop, is applied to this image.

Digital Composition or Collage

If one standalone photo is not enough for your project, another approach is to piece several photos together, creating a collage. Using several photos together often can present a concept or theme better than one single image.

The Least You Need to Know

- Photos can be used to show readers a person, place, or thing, as well as to evoke an overall mood.

- The best fit for a horizontal space in your design is a horizontal image—the same goes for a vertical space. However, you often can crop and resize photos to fit the shape of the opening you have.

- The standard resolution for images to be printed is 300 dots-per-inch (dpi), while the resolution for electronic images used on the web is 72 dpi.

- To be sure the images you have are of high-enough resolution, take them or download them in a larger size than you think you need. You can shrink a photo and improve its resolution, but when you enlarge it, you lose resolution quality.

- Special effects and image manipulation tools make it possible to change the light balance, color, and overall impression of photos, as well as removing distracting subjects.

Illustration

Designs are richer-looking that contain a range of image types, from photographs, to computer-generated images, to illustrations. That is, they're more interesting, more complete.

But illustrations are much more than just clip art, which is what people often think of when they hear the word. Illustrations can be technical drawings or they can be very artistic and individual. What will work best in your design is both a matter of the tone you are trying to set with the piece you're creating and your own personal preference.

Approaches

Depending on the situation, time, and money available, many kinds of illustrations may be appropriate for your design. The first choice you'll need to make is whether technical illustrations, consisting frequently of line drawings, is best, or whether stylistic, more artsy, illustrations will better reflect your desired theme and tone.

Technical

Technical illustrations are frequently used to present a true-to-life look at a product or process. The style is realistic, almost minimalist, and the purpose is to show something that is more difficult to spot in a photograph.

CAD drawings, generated by computers and printed on large-format printers, are also a good example of technical illustration, as are architectural drawings.

© Jim Downer

Technical drawings highlight important parts or processes with ease. Here the technical drawing shows the specific measurements for the ball-in-socket structure of this animation armature.

Typical uses of technical illustrations include these:

- Owners' manuals
- How-to guides and books
- Usage instructions enclosed with products
- New product announcements

The diagram (top) shows a detailed version of a component of the avionics unit (below).

Figure 1.6.
SRC cross section
(SRC hinge is separated from SRC prior to release).

Figure 1.7.
SRC prior to installing thermal closures – avionics box A and the LiSO₂ battery in foreground.

Figure 1.7 shows the avionics unit A and the flight battery prior to installing the thermal close outs. The collectors are partially deployed. Also visible in the upper left is the cable management system that restrained the cable between the heatshield and backshell during backshell opening and closing.

Image courtesy of NASA

Technical illustrations are fairly standard in terms of style, with illustrators typically using pen-and-ink to create them.

© Kathleen Brien

This image, done in a photo-realism approach, looks like a moment in time captured on canvas.

Stylistic

Nontechnical illustrations, which we're terming "stylistic," are drawings and paintings created by artists in a variety of techniques, styles, and media.

Here are some of the common stylistic illustrations categories:

- Photo realism—Drawings that look almost like photographs
- Scratchboard—A technique using black clay board where the artist "scratches off" a portion to create the image
- Cartoon—Line art that is usually colored in, resembling television cartoons
- Line art—Pen or pencil drawings, often without color added
- Stylized realism—Stylized realism is similar to photo-realism in that it represents regular activities or events in a true-to-life fashion. The major difference here is the drawing, or illustration style, is less photo-like and much more illustrative. Think Norman Rockwell as a good example, he used everyday situations for his painting subject. This type of illustration is often seen on greeting cards.
- Digital—Entirely created using a computer. Perhaps using scans of sketches, but drawn using a vector-based program
- Technical—Illustrations done generally with pen and ink, or computer, to create line drawings showing technical aspects of machinery or other items. Often used to show instructions for assembly or other diagnostic reasons.

The type of illustration you select can help create the overall tone you are setting in your design. For example, a subdued watercolor scene might be a perfect addition to a capabilities brochure for an independent living facility. With the soft tones it can perfectly convey a sense of nature and a peaceful environment. However, if your design is more business-to-business focused, the soft lines may not be as professional-looking as other styles. A technical drawing, a photorealistic portrait of the company CEO, or other type of image may be more appropriate. Many mediums, or methods, used to create images can be appropriate to specific needs, another factor to consider is what is the overall style of other collaterals used by the company and personal preferences of the client. These will also influence decisions.

© Jim Downer

Clean lines and bolder colors can help present a humorous look, useful for corporate communications.

Media

Specifying a technique is one way to choose an illustration that supports your design, but stating a preferred media is another. For example, an ethereal watercolor may match the look and feel you're going for, better than the heavier brushstrokes and colors typically found in oil paintings. Or a 3-D collage may enable you to pull in several related elements into one illustration. Some magazines today use contemporary paper-cutting as a way to create a three-dimensional effect in their "Feature Section" headings.

© *Jason B. Smith*

This mixed-media illustration would be a perfect accompaniment to an article about navigating retirement investment options.

Paints and Inks

Some illustrators use traditional art tools like paints, pastels, inks, and colored pencils to get their pictures onto paper.

The advantage of liquid-based art tools is their ability to convey feeling or evoke emotion. If your design aims to make recipients feel a certain way, hand-painted and hand-drawn illustrations may work especially well.

Common illustration media include these:

- Watercolor paints
- Pencil or charcoal
- Pen-and-ink
- Tempera

- Acrylic
- Gouache
- Pastel

Each of these illustrations, paired with an appropriate article, could evoke an emotional response.

An old technique with a twist, collage has been cropping up in connection with very stylish brands.

© Kathleen Farrell

Objects

Although paints and pens are popular illustration tools, artists today are frequently incorporating other objects into their illustrations.

Contemporary illustration elements include these:

- Paper-cutting or tearing—This artful technique uses different colored and patterned paper to create a three-dimensional design that is then photographed. This photograph is then used in a two-dimensional design.

- Collage—This method can be actually or digitally created and is a layering of images, sometimes 'pasted' on top of other images, colors, or patterns. Often contains actual objects and typography.

- Assemblage—This artistic process is a notch up from it's cousin Collage, but moves squarely into the three-dimension, its composition is created of found objects.

- Digital scanning or creation—Many of today's artists use this combination to create their work starting with sketches or pen and ink drawings then scanning them and moving to work on the computer to complete.

When dealing with several elements to be incorporated into an illustration, it's useful to choose a theme to guide what will and won't be included. For example, do you want to show elements of nature in general, or are you really focused on Spring flowers?

Assemblages can be used to feature objects from a particular locale, of a certain type, or of a certain age, color, or shape, for example. Their flexibility is what makes them so popular as illustration tools. Artists frequently create assemblages using related objects, such as wasteful packaging or sewing tools, and then photograph them or scan them for use in a collateral design, depending on size constraints. Sometimes size prohibits scanning and then photography is the only method to use.

Here the artist has worked found objects and sketching together in this combined piece. This might work well to accompany an article on architectural design.

© Jason B. Smith

Converting Files to Digital

Many illustrators today are familiar with the needs of graphic designers, who are typically creating digital files. So even if illustrators are creating on paper, many know how to convert them to a digital format.

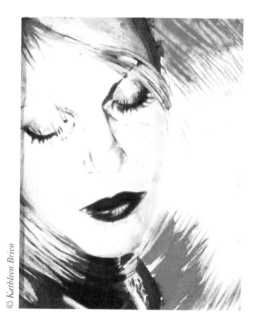

Here the artist worked in wet medium, and then photographed the work so it could be used digitally.

© Kathleen Brien

Creating Digital Files from Scratch

Illustrators with digital experience generally will ask how you'd like your file delivered—in hard copy, so you can convert it yourself—or as a *JPEG, TIFF,* or *GIF* file.

By saving the illustration in a particular file format, it can then be copied to a CD or e-mailed directly to you for incorporation into your design.

The most common digital file format for images is a **JPEG**, which stands for Joint Photographic Experts Group—the group that created the file format. Macs and PCs can generally process jpeg files, although **TIFF** (Tagged Image File Format) and **GIF** (Graphics Interchange Format) files are also fairly common formats.

These images were created with pen-and-ink, and then scanned and colored using the computer.

© Jim Downer

Digital Reproduction

If you're handed a hard copy illustration, on the other hand, it's up to you to convert it to a digital format before you can incorporate it into your digital design file. There are two main ways to do this:

- Scan the image at a high resolution.
- Photograph the illustration at a high resolution.

Both techniques are effective when the correct steps are taken for both processes. Lighting is a big factor in the photographic method, and the correct size and type of scanner used is key for that method.

If your own scanner isn't large enough to accommodate the artwork, it's best to have it scanned professionally rather than piece the work together digitally. If you piece it digitally, you run the risk of not matching the work appropriately. And, if the artwork has depth or uneven surfaces, this will make the job even more challenging.

Hiring an Illustrator

To find possible illustrators to create the images you need, turn to some of the following sources to get started:

- Annual books of award-winning illustrations
- Colleagues, to ask for referrals
- Websites showing illustrators' works
- The Yellow Pages

- Local artist associations
- Ad agencies, which may use illustrators frequently

When you've compiled a list of at least three illustrators, ask to see their *portfolios*.

As you review illustrators' portfolios, pay attention to their style, the subject matter they seem most comfortable drawing or painting, and the breadth of techniques they use. Do you like most of their samples? Are any similar to the look you're after? Unless the answer is yes, keep looking elsewhere.

Once you select an illustrator and discuss the project, be ready to pay a deposit to get the person started on your work.

The Least You Need to Know

- If you're designing a technical user manual or how-to guide, a technical illustration or line drawing is probably most appropriate to highlight a particular aspect of the product or process. But if you're designing a marketing piece, you may want a more artistic style.
- There are several styles of drawing and painting as well as different media that illustrators use to create images.
- To find an illustrator whose style fits the piece you're designing, you'll want to review the portfolios of several illustrators who work in the media you prefer, whether it's watercolor or paper-cutting, for example.
- Be sure to negotiate your usage agreement up front, so you know how you may and may not use the illustration you are interested in. If you expect to use it in future designs for the same company, negotiating an unlimited usage agreement may be more economical.

PART 5

Grids and Templates

Now that you've gathered all the elements you need for your design, you'll learn some strategies for laying them out effectively on the page. You can use grids to align everything, much like graph paper helps keep components organized; you can even start with a page template, which already has recommendations for placement of your images and text. Or if you've created a design you want to reuse, we'll show you how to make your own templates. And once everything's in place, we'll show you how to create comprehensives, or comps, to show your boss, client, or friends, for feedback.

IN THIS CHAPTER

- Using grids to organize the page

- Reorienting the focal point with grids

- Reinforcing visual hierarchy

- Avoiding inconsistency

CHAPTER 14

Organizing the Page

Grids are vertical and horizontal lines that can be applied to paper to help graphic designers better organize all the information they're working with. These lines provide the underlying structure used when forming a visual hierarchy; they make text and graphic alignment easier during the design process.

The Swiss actually developed grids as a design tool in the mid-twentieth century, and American designers adopted the practice soon thereafter. Today some designers swear by them. While they are an optional tool, they are a good one for new graphic designers to use as a starting point.

Grid Types

Although grids have a single purpose—better organizing text and images within a design—there are a number of grid schemes you can use:

- Manuscript or one column
- Multiple columns
- Modular columns
- Hierarchical grid

One, Two, or Multiple Columns

One-column grids use the entire page, while two or more grids divide the page into rows and columns for easier information placement. Columns are vertical sections, whereas rows are horizontal, just as you see on spreadsheets. On a grid, both columns and rows can be of varying widths and heights.

© Northeast Dental & Medical Supplies, Inc.

You can set up one-column grids in virtually any program, including Microsoft Word, because the entire page is essentially its own column.

When grid lines are turned on in your software program, you can clearly see how many columns you are working with, but in the final design, it sometimes can be difficult to identify how many columns are in use. That's because the columns are really for your use in organizing all the components of your design and aren't necessarily integral to the overall look.

It might be easier to understand the grid concept if you think of the way a newspaper is organized. Newspaper publishers often use justified type, which is even on both the right and left sides of a column, making the space between columns a fixed width. So no matter how many columns your design involves, an advantage is that information is organized and easier to understand because of the structure.

This may look like a three-column format, but there are actually five columns in use.

Creative License

Adobe products let you turn grids on or off when setting up columns, giving you the flexibility to use them or not, as you prefer.

Portrait or Landscape

The size of the page, or whether it is oriented *portrait* or *landscape*, do not matter—grids can be used in all situations.

An advantage to using grids, is that the information is better organized, helping to lead the readers' eye to each part of the overall message. But that doesn't mean grids have to be constraining or restrictive, in fact, grids don't always have to fall on a precise horizontal or vertical axis. The Dada and Bauhaus artists of the early twentieth century often used the grid on a 45-degree angle, creating a dramatic effect. The sole purpose of grids is assistance in organizing design elements in a systematic way.

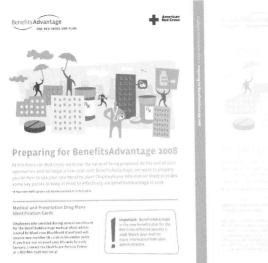

Preparing for BenefitsAdvantage 2008

Here is what a portrait layout looks like with grids.

And here is a landscape-oriented layout.

Use of White Space

Grids function much like graph paper, helping you place text, photos, illustrations, logos, and other design tools on the page in a visually pleasing way.

One of the by-products of good design is effective use of white space which also leads to better legibility. Said another way, strong design does not clutter the page with too many elements. Plenty of white space—where the blank page shows through—makes it easier for the eye to gather and process information because your brain is not overloaded with too much detail.

White space is used to create a sense of elegance and refinement. The more white space that is used, the higher the perception of luxury, while using less white space in a design is often perceived as cheap.

White space provides the viewer clear contrast to see the groupings of information.

© stressdesign

Collaterals designed with generous use of white space are more inviting and easy-to-read, giving a sense of overall simplicity. Many upscale brands make use of it for a classic look. Read design magazines and look at online design archives for good examples to study.

Unfortunately, bad examples are all around us. From the newspaper ad so crammed full of text that it is hard to focus on any individual words, and which certainly has no white space to be found, to direct mailings that push text up against photos and illustrations, causing the eye to nearly cross when trying to distinguish between image and word.

Reverse Type

Although black print on white paper is the easiest to read because of the maximum contrast, that does not mean that white print on a black page is equally easy to read—it's not. Termed "reverse type" because the lettering is lighter than the background, this technique should be limited for best readability.

Focal Point

Grids can be used to move the natural focal point, which is in the center of the page, to draw attention to important information elsewhere on the page.

Text

Although our natural tendency is to look first in the center of a page, because the English language is read from upper left to lower right, English speakers have a tendency to look in the upper left of a design first. On the other hand, speakers of other languages focus their gaze first at the beginning of their page—such as the upper right. The designer's role here is to lead the viewer around the page by using graphic elements, such as white space, imagery, and visual hierarchy—all supported through the use of grids. Using natural elements in photographs as alignment tools provides a variation on grid use that seems less grid-like but is still structured.

In the two websites shown in Figure 7, the end of the swimmer's hand leads the viewer directly to the important type message, and the bridge leads the viewer across the entire screen in the second image. More formal grid structures are evident in the navigational areas at the top and bottom of the frames.

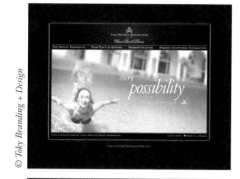
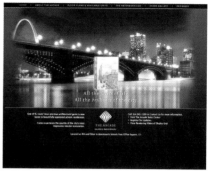

© Toky Branding + Design

Both of these sites make good use of the imagery as essential components to lead the viewer through the page.

Graphics

Grids can help place images, illustrations, and other graphic elements on the page so that they're properly aligned with the copy, or text. It also can help you visualize how prominent the graphic is in relation to other elements on the page, which is helpful for building a visual hierarchy.

© Coburn Design

Grid structure is crucial to the readability of these page designs.

Using Elements and Principles of Design

The key to proper use of grids is consistent use; using the lines inconsistently produces a confused design.

Smart Use

When dealing with several design elements, such as copy, a corporate logo, multiple photos, and a pull quote, grids can help place all the pieces in an organized way.

Grids are useful for organizing information, but don't assume one grid works for all uses. Sometimes you must use several grids, or variations on a main grid.

© stressdesign

Grids provide a system to aid in proper design. In these multiple designs, you can see an overall grid in use with some slight variation.

Grids are very flexible and can be modified to meet virtually any need; you just need to be creative sometimes in your use. You also can break up a page horizontally, and use different grids at the top than the bottom, depending on need. Just don't go overboard

and try to mix them together for everything. Sometimes different grids are used for different types of information. If you're uncomfortable using them, start simple. The key is consistency in use.

The Least You Need to Know

- Grids are vertical and horizontal lines that can be applied to paper, to help graphic designers better organize all the information in a layout.

- There are several grid schemes, or layouts, you can use: manuscript, one column, multiple columns, modular columns, or hierarchical grid.

- You can turn grids on or off in Adobe software programs.

- When dealing with several design elements, such as copy, a corporate logo, multiple photos, and a pull quote, grids can help to place all the pieces in an organized way.

IN THIS CHAPTER

- Saving time with templates

- Learning design construction

- Working with what you have

- Designing your own templates

Templates

Design blueprints, also called templates, can be a terrific solution if you lack inspiration or time. Templates provide a general layout into which you can flow images, illustrations, and copy, and it certainly can speed the process along if you can find a look you like.

The downside of using templates is that your design will be very similar to other designers' work. That is, any originality and design flair will be effectively eliminated. In a pinch, however, templates can provide a way to get the job done when you wouldn't be able to otherwise.

Available Options

There are many websites that provide templates for download—some for free and some for a fee. However, the best place to start is within the software programs you already use. Even Microsoft Word has a plethora of templates for all kinds of documents.

Software Templates

If you don't find what you need in the templates folder of the software you're using, you can find plenty more through a Google search for the type of template you're after. You should have no trouble finding a *shareware* template for a business card, letterhead, newsletter, brochure, blog, or website, for example.

Be aware, however, that most designers stay away from templates as much as possible, so that their pieces stand out as original. And they're not available in all software. Adobe removed templates as an "extra" in their latest version of InDesign CS3, but there are still plenty of them available online.

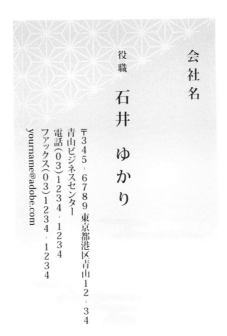

You don't have to look far to find decent templates. This one is from Adobe Illustrator.

APPLICATION	VERSION	DATE / CREATED
Adobe® Indesign	cs	06.01.07
SIDE / ORIENTATION	DESCRIPTION	
Vertical	3.5" x 8.5"	

3.5" x 8.5"

BLEED - To create the 1/8" bleed, to ensure that ink coverage goes to the edgeof the final trim size, extend any graphics/artwork to the edge of this template.

SAFETY GUIDE - No text beyond this line.

TRIM - This is the actual cut line of the final trim size/ size ordered.

Free templates are not difficult to find online. This one is provided by an online printer.

Modifying the component parts of a free template enables you to keep the overall design structure of your collateral the same, and allows for visual variation for future releases.

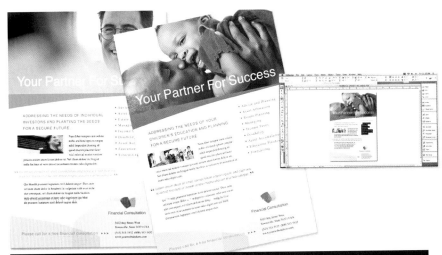

See how easy modifying a free template can be? The screen shot shows how text can be modified once other components have been changed and placed.

How to Choose One

There are two general ways to search for an appropriate template: either by format or by software package.

Type of Design

Sometimes the fastest way to find what you need is to search by keyword, looking for templates of types of designs. That is, use newsletter template, ad template, or blog template as the search words.

Although templates will give you a layout, sample images, color, and *Greeking*, you can change nearly every element to fit your needs.

When you see nonsensical text in a sample layout, generally starting with words like "Lorem ipsem dolor sit amet," that is **Greeking**. The words mean nothing, but help graphic designers envision what the completed copy will look like on the page.

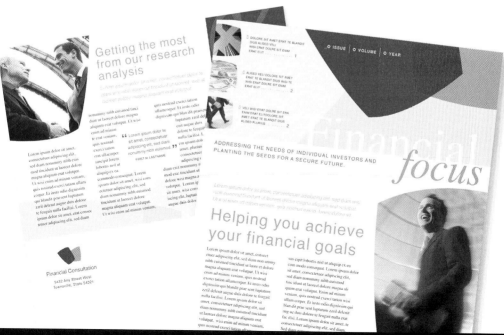

Newsletter templates are some of the most popular because of the potential time to be saved in not having to start from scratch. Replace the text with your own words and you're set to go.

Greeking also helps copywriters estimate how much space is available for the text they need to produce.

Software

Another place to start in your search is with the software package you're using. Depending on the software and how old it is, you may be limited to certain types of templates; if you're using an older software version, templates designed in new programs may not work. If your current version has no templates, like in Adobe InDesign CS3, check the help menu. Sometimes directions for making your own are there.

Of course, one way to increase your options is to upgrade your software program to the latest and greatest, but sometimes the cost can be prohibitive.

Sometimes directions for template-making steps can be found under the "Help" menu.

Making Your Own

In addition to using someone else's template as a starting point for your work, you can also use your own work as a template. It's as easy as saving a finished design with a new name, or in a template format.

Setting Up Guides

One way to make your own template is by building a document from scratch, using guides and columns.

After you've created the structure the way you like it, you can start filling in the design elements.

The Save-As Command

Of course, there are even simpler, less formal ways to create a template. If you decide a design you've created is a smart starting point for other designs, simply open up the original design and use the "Save As" command to save it under a new name. Then you can start to make modifications while keeping the original design intact.

The Least You Need to Know

- Templates can provide a way to quickly begin a design, which is helpful when you have a short deadline.
- Many templates feature fairly simple designs, which can lead to a plain or bland designed piece. That is one of the reasons that graphic designers don't often use canned templates.
- Most software packages come loaded with templates, which is one place to start. But you also can search for templates online, which are frequently low-cost shareware programs.
- If you have a design you've created that you'd like to use as a template, you can simply open it and then use the "Save As" command to open a new file, using the original design.

Creating Comprehensives

Comprehensives, or comps for short, are the compilation of all the work you've done so far on your design—the final step.

Once you've laid out the copy and images, and you are ready to reveal your draft design, the final printout you prepare for show is called the comp. It is comprehensive since it contains all the design elements the client asked for (or all the elements you believed were needed).

Assembling

The purpose of a comp is to give your client, whether that is your boss, a committee you're on, or an outside company that has retained you for design assistance, a look at what the finished piece you've designed will look like. These are not the same as thumbnails—thumbnails are at the beginning of the process and comprehensives are near the end, just before production or printing occurs.

The number of comprehensives you make should not be excessive; they should number two or three on average. By the time you've gotten to this stage, you should have a clear understanding of what the client wants. After all, you've already shown the client thumbnails and discussed in depth most of the audience, competition, budget, and marketing needs. Most designers do a lot of thumbnails, and generally three or four refined concepts before the comprehensive stage. Creating comprehensives generally is done for the final, refined, and nearly completed design stage. Preparing comprehensives of two or three of the final concept(s) is normal; however, many times there are corrections and some variations that come from this late-stage review.

While pulling all the elements of your design together creates the official comp, the other component you'll also want to review is the paper you plan to use, and whether or not it will need to be finished in some way, such as folding, stapling, or binding.

Paper

To ensure that your client is happy with the look and feel of the paper you've specified for your project, it's always a good idea to create a *dummy*. If you're working with a commercial printer, your representative likely will create one for you; however, if you're producing it in-house, you'll want to prepare one yourself to show your client.

That means getting a sample of the exact paper you plan to use, and then cutting it down to the finished size, as well as folding, stapling, or gluing where you anticipate such finishing.

© Rizco Design

These dummies show
how a brand looks
applied to various
objects used in busi-
ness.

Finishing

Depending on the type of project you're completing, there may be additional work to be done on the paper itself, in order to finish it. That includes folding, scoring, stapling, or binding it.

Client Presentation

One of the primary uses of comprehensives is to elicit feedback from your client—to get their reactions and input so you can finalize your design. Your goal is to hear constructive comments that will help you further refine the design to best meet their needs. You can only do that with input regarding the layout, colors, images, format, and anything else that jumps out at them. Your hope, of course, as the designer, is that they will absolutely love it as-is. Realize this almost never happens on the first go-round and be prepared to tweak your comps a bit.

Creative License

To spiff up the look of your design, mount it on black or white foam core, with a slight border, or without one. This approach helps unify all the comps you have to show, and gives them some extra weight.

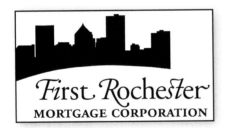

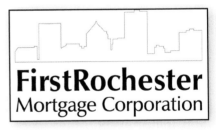

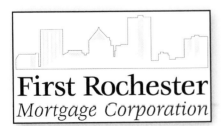

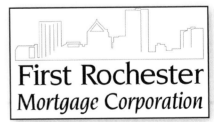

You generally see more than one comprehensive presented, in order to give clients more than one option to choose from.

What to Do About a Negative Response

If the client doesn't like any of the comprehensives this is where both the designer and client renegotiate for further work, or a "kill fee," a previously-agreed-upon fee for stopping the project, is paid and the client engages a new designer.

A graphic designer worth his money usually doesn't reach the point of a kill fee, but sometimes it is best to part company. Most designers will do one or two revisions to refine the comp to give the client what is wanted. More than that and you have to wonder if you will ever reach consensus. It may not be possible.

Many times issues around design ideas are fully explored and incompatibilities are discovered earlier in the process, thus avoiding a situation later where you discover you are not on the same page.

Be careful about the presentation of colors, however, because you know that the colors will look different depending on whether they've been calibrated for online, digital, or commercial presses.

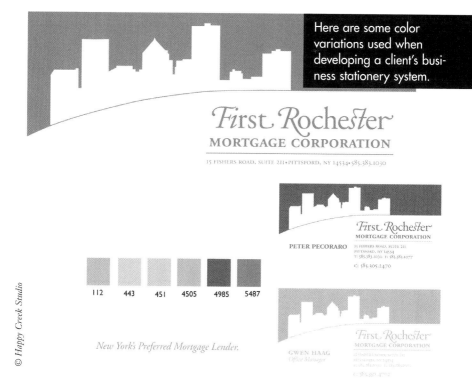

Here are some color variations used when developing a client's business stationery system.

112 443 451 4505 4985 5487

New York's Preferred Mortgage Lender.

© Happy Creek Studio

Make sure the color you show accurately reflects the true output you have planned. Or work with your commercial printer to have them match the color sample you showed the client, which they approved. Pressmen are truly a designer's friend and can often match ink colors exactly.

It's also a good idea to present a few variations of your favorite design, to show your client alternatives. Presenting different colors, different placement of the corporate logo, or different typefaces are all part of a designer's responsibility, and they are useful for your client to see.

USPS Presentation

Another reason to create a comprehensive is to present it to the United States Postal Service (USPS), to verify that it meets their mailing standards. Many post offices in larger cities have main facilities where mail standard specialists work. These professionals are a designer's friend, as they often offer suggestions to help your mailed design successfully traverse the automated machinery and arrive unscathed in a mailbox.

The United States Postal Service has business postage specialists available to counsel you on your designs.

By bringing in a nearly complete layout, you can confirm that it won't be rejected and/or that it is within federal guidelines for first-class mailing. (Better to find out now that it's ⅛-inch too long, rather than after you've had 10,000 printed up.)

The Least You Need to Know

- Comprehensives enable your client to see your completed design, with all of the elements in place.

- To show what the paper will look and feel like, you'll also want to prepare a dummy, which is also called a mock-up.

- When presenting comps to clients, it's a good idea to dress them up by gluing them to some kind of backing, such as black or white foam core.

- Showing the United States Postal Service your comp is a good idea, too, to confirm that you are within federal regulations for your type of mailing.

PART 6

Putting It All Together

The smartest graphic designers rarely start from scratch when creating a new brochure, website, or logo—they head to their "swipe file" to skim designs they've seen and like. Although you never want to copy another designer's work, you can certainly get ideas and inspiration by looking at the work of others. In this part, you'll see great examples from designers all over the country, to spark some ideas for new and different ways you can approach your own designs. Whether you're working on a direct-mail piece, letterhead package, promotional product, or something entirely different, you're sure to get some new ideas from the many great examples here.

CHAPTER 17

Advertising

Advertising is perhaps the best-known marketing tool, because it's been around forever. In exchange for money, you can use newspapers, magazines, newsletter, websites, television stations, radio stations, billboards, and just about any other type of media, to present your message to their audience. But not just any message—this message is created by you to ensure it says exactly what you want it to.

You design it—including approved copy and images, pay the required advertising rate, and then, at the appointed hour or day, your ad will run in the media you specified. The key is coming up with a design that will catch the attention of those who see or hear it.

The key pieces of information you'll need before you start designing, however, include the ad's dimensions, color (whether black-and-white or spot) due date, and the key message to be conveyed.

In this day of media saturation—ads in church bulletins, ads on television, and ads on your web browser—a good ad needs to be visually distinct to catch our attention. Well-crafted ads have all the necessary information, such as dates, times, and places, but also have an aesthetic sense or visual hook to get you to take notice.

Print

Whether your audience is comprised of consumers or businesses, print media can be a good choice, especially if you have a somewhat complicated product to explain or service to introduce. The major advantage of print advertising over online or broadcast is that many readers tear out an ad or share the publication, so the *reach* and longevity of the ad is longer.

Size

The size of print ads are limited by the total size of the publication and set by the advertising staff. So if the magazine is a tabloid size, meaning 11×17-inches, then the largest ad you can buy is a little less than 11×17-inches, leaving room around the edges for page numbers and the magazine's name. However, you'll typically find a long list of possible sizes available.

In advertising lingo, **reach** refers to the number of people who are exposed to your ad. The reach increases as more people read the magazine. And with pass-along readership, the numbers can go higher. The more people who see it, the lower your cost per impression (CPI).

Many publications today have their ad rates listed online as part of a downloadable media kit. If you cannot find what you need, simply call the advertising department and request its media or advertising rates packet. It is happy to send any potential customer this information.

So the first step before committing to an ad contract is to determine what your budget will allow. Some sizes will simply be too costly to consider.

In addition, you will see better results from repeating a smaller ad several times than from pouring all your resources into one humongous piece. Yes, it may be easier to create an attention-getting full-page ad, but you can certainly design an effective quarter-page ad, too.

The key with smaller ads is to focus on one message, not several. Generally, that means limiting the amount of copy in the ad, so that the typeface size can be large enough to be read easily by the

casual reader flipping through the publication. Don't try to do too much in a single ad. If need be, plan on a series of several ads over several issues.

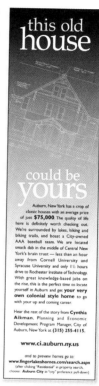

Print ads come in all shapes and sizes.

Placement

When designing a print ad, it can be helpful to find out where in the publication it likely will appear. Of course, the best place to be is as far front as possible, which you may have to pay extra for.

If you can't be up front, study your fellow advertisers in the back to see how they've approached the space they've been allotted. Then look for a way for your ad to stand out.

For example, if the other advertisers are using color, stick with black-and-white. If they are copy heavy, be very sparing in your use of text. If they don't have any photos, use one. Or if they are all using photos in their ads, consider using an illustration instead.

The key is to stand out, no matter where your ad appears in the publication. But if you're not pleased with your ad's placement, see if you can get moved closer to the front on the next issue.

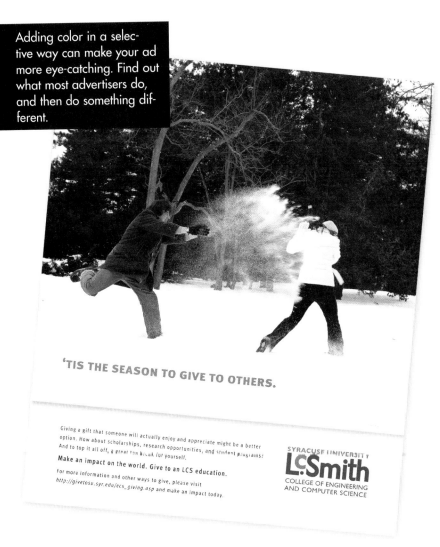

Adding color in a selective way can make your ad more eye-catching. Find out what most advertisers do, and then do something different.

'TIS THE SEASON TO GIVE TO OTHERS.

Giving a gift that someone will actually enjoy and appreciate might be a better option. How about scholarships, research opportunities, and student programs? And to top it all off, a great tax break for yourself.

Make an impact on the world. Give to an LCS education.

For more information and other ways to give, please visit http://givetosu.syr.edu/ecs_giving.asp and make an impact today.

SYRACUSE UNIVERSITY
L.C.Smith
COLLEGE OF ENGINEERING
AND COMPUTER SCIENCE

© stressdesign

Color

In print ads, adding color can double the cost of the ad, because the publication has to use a different process to print the page. Designing the ad in color, however, costs nothing extra and can improve its effectiveness, depending on what is around it.

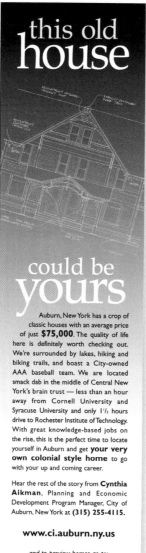

Using color can help differentiate a black-and-white ad for only a small additional charge.

Here the green accentuates the name of the company.

Web

Websites are their own advertisements, and we talk about them in Chapter 23, but if you want to place your own ads on other websites, there are some design rules to be aware of.

Most online ads are in the form of banners that run above, below, or alongside a website. They are thin rectangles, which does not leave a lot of space for images or copy. You must get the pixel-by-pixel count needed for banner ads from the sites where you're placing your ad. Remember to include the specific details you want advertised—especially your contact information.

If you can find a website that appeals to your target audience, a banner ad can be a smart investment.

24TH ANNUAL CEAA ENGINEERING CONFERENCE

April 20-21, 2007

The Impact of Globalization on Business and Technology

www.ceaa.cornell.edu for details and registration information or call 1.607.255.9920

With the increasing use of video, more companies are running streaming video ads, too; however, designing them is more of a broadcast-production challenge than a graphic design project.

Creative License

If a banner ad on a particular website is too expensive, look into the cost of placing a small ad in the company's e-mail newsletter. You may be limited to text, but often a newsletter ad—that goes to people you know are interested in that type of information—gives you more bang for your buck.

Banner Ad Sizes

Banner ads are not designed to generate immediate responses or click-throughs to your site. Instead, they are an awareness-building or anchoring device. After seeing them a few dozen times, you might decide to click on them and discover what they offer, but rarely does that happen in the first few viewings. Pricing for banner ads is based on impressions, the number of times they'll be viewed, not selected. There are also several sizes and formats to choose from.

The main difference between print and web ads is that there are few size options online. Two or three variations are standard, and color is included, because there is no additional process involved in production.

Electronic Considerations

Designing for the web requires an eye-catching image, first and foremost, followed by a catchy headline that draws the visitor in. The goal of a banner ad is to get the prospect to click on it, to go and explore your company's product or service. That's it. So give people a picture and some words that will make them want to find out more.

Vertical website ads can work, too. This black-and-white version is a good contrast on a colorful page.

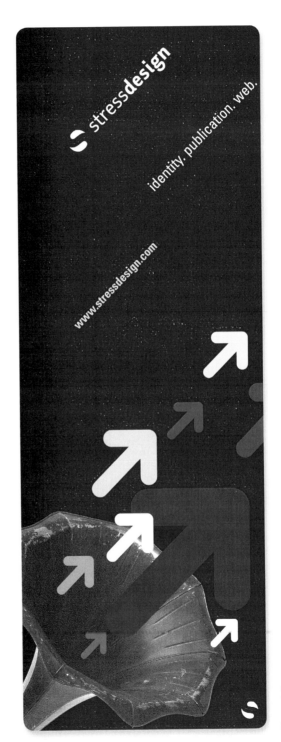

© stressdesign

Large Format

Not all advertising is small enough to fit in a newspaper or on a computer screen. Advertising can take place outdoors on billboards, signs, and posters. These categories are considered large-format advertising.

Designing for a large format is both a science and an art. It is a science because there are ratios for determining the size of the image and copy that works best; it is an art because even with the proper ratios, if your design isn't tantalizing, you will have failed.

Posters

Posters can be produced on a large scale, to be placed in a store-front window, for example; they can also be produced on a smaller scale, to be taped to doors, windows, and bulletin boards.

© Happy Creek Studio

Posters have one main image and message, followed by the fine print.

Special-event posters are often printed in color, but the more economical approach is to print black on colored paper.

© Happy Creek Studio

There is more than one way to introduce color to a poster. This is the less expensive way.

Signage

Signs are useful indoors and outdoors, for directing traffic to the appropriate place or person; for identifying addresses, buildings, and companies; or to supplement a tradeshow display or presentation.

Although we rarely notice signs, when they are well designed and well located, they make life easier for all.

© Beth Singer Design

Almost any building or organization has a multitude of signage needs, if they really take a minute to consider them:

- Department names
- Building street address
- Exterior company name
- Directional indicators (exterior and interior)
- Individual names on cubicles
- Signs providing instructions
- Warning signs
- Special-event announcements
- Promotion offers
- Product labels

As the designer, you may be asked to coordinate a signage effort, in which case consistency is the key. You also may be asked to

create a design manual to specify the particular typeface or color used, for example.

Designers may also need to research town and city zoning regulations before finalizing signage. And outside vendors may also be needed. A graphic designer can create beautiful graphics, but if the need is a large, backlit sign, then employing a sign-making company is essential. Working with local vendors can also be a help when trying to work within zoning requirements.

Billboards

The largest type of advertising tool is the billboard, which generally is placed alongside a major roadway or on the side of or above a building. The dimensions are generally similar, and the billboards are available from outdoor advertising companies that lease the billboards on a monthly basis.

However, a new trend is to have "movable billboards" driven around your community. The size of these moveable billboards is different from the stationary variety. Likewise, many athletic stadiums and transit companies have billboard advertising that is different in dimension than traditional billboards. Most, however, have some identifying name listed at the bottom of the space, so contact that company to find out all of the available advertising spaces you have to select from.

SCHWEINFURTH MEMORIAL ART CENTER
205 Genesee Street • Auburn, NY 13021 • (315) 255-1553

because

Crayons are for more than writing on walls

www.myartcenter.org

© Coburn Design

Billboards often are seen by tens of thousands—even hundreds of thousands—of people a day, depending on the location. Even a simple black-and-white billboard can be very effective.

Check with the advertising department at any of these venues to learn about available sizes.

Don't forget to check with your community, too. Some areas put up banners on light poles promoting the community. Some are incorporating advertising cooperatives with local businesses as a way to finance the banners.

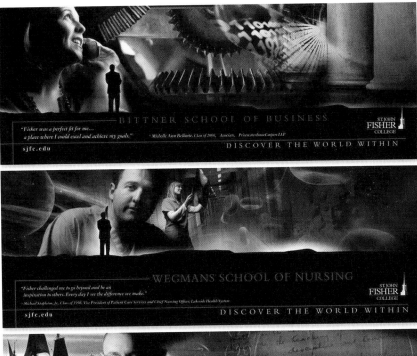

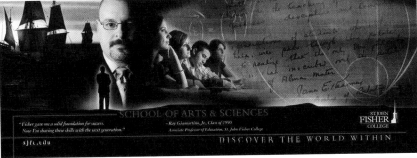

Several billboards designed with the same theme, but different images and headlines, can be very memorable.

Images courtesy St. John Fisher College

The trick with billboards is to design for the person who is driving by at 60 miles per hour. She may be aware of the billboard for mere seconds; what kind of image and headline can you provide that will stick with her and cause her to either head to your client's business, use your client's product, or remember your client's message?

For more complex messages, or in the case of an advertising campaign with several components, a series of billboards may be the better option: It takes seven to nine impressions before someone processes what he has seen, and makes a decision about whether he may be interested in buying. It is harder to hit that magic number of impressions with just one billboard.

Just because your format is large, don't forget to employ the techniques you learned earlier in this book. The same principles and elements of design apply here, too. Keep the information legible and readable at speed—less is definitely more here. If your target audience is contained for a period of time, like on a bus or train, then you can use more complex and involved typography.

The Least You Need to Know

- Advertising is the one media in which you control where and when your marketing message can be seen; this makes it a useful tool.

- Print advertising is very popular with business-to-business audiences who turn to newspapers and magazines for guidance. Because print media is passed around and saved, the ads within the newspapers and magazines also have a longer useful life than, say, a television ad.

- Web advertising today consists mainly of banner ads that run above, below, and beside websites. Although video is becoming more prevalent, graphic designers play less of a role in their creation and production.

- Large-format advertising, such as billboards, signs, and posters, need to be legible, first and foremost. Outdoor ads also have to be created for people whizzing by at 60 miles an hour, who have only a second or two to take in the key message.

- Creating coordinating correspondence tools

- Using paper and color to complement

- Trade-offs to be different

- Nice but economical add-ons

Stationery Package

First impressions are important in life and in business. How employees dress, how customers are treated, how well the product or service performs, all shape the perception of a company or a brand. A lot of times, though, the first contact your company or client may have with a potential customer is through their business card or a letter sent on their letterhead—both elements of a stationery package.

What a piece of stationery looks like, how the paper feels between your fingers, whether it coordinates with the enclosed business card—these are all minor factors that we, as human beings, process almost instantaneously. And our reaction to what we see and feel affects our initial feelings about the company whose name is on the letterhead.

Nearly every professional needs the basics shown here.

Components

A stationery package is generally defined as a selection of printed materials used for correspondence and daily business.

So what should a well-designed stationery package include? There are the basics:

- Letterhead
- Envelope
- Business card

However, there are some extras—some "nice-to-haves"—that can be added to the printing job very economically if you're having everything printed at once. These include the following:

- Mailing labels
- Large envelopes with pre-printed return address
- Invoices
- Other pre-printed forms
- Pocket folders
- Stickers featuring the company logo
- A simple flyer or tri-fold brochure

© *stressdesign*

Although a small business might not need all of these elements, a larger organization certainly could.

Visual Elements

What makes a stationery "package" a package, however, is a unifying theme—a design element or elements that ties them all together.

Logo or Mark

The most common unifying element is the organization's logo or mark, which should be featured on all of the pieces of the stationery package, as well as on other *collaterals*.

© *Rizco Design*

Here the logo, shown in green, has been used for both the pattern on the bag and to brand the product on the tag.

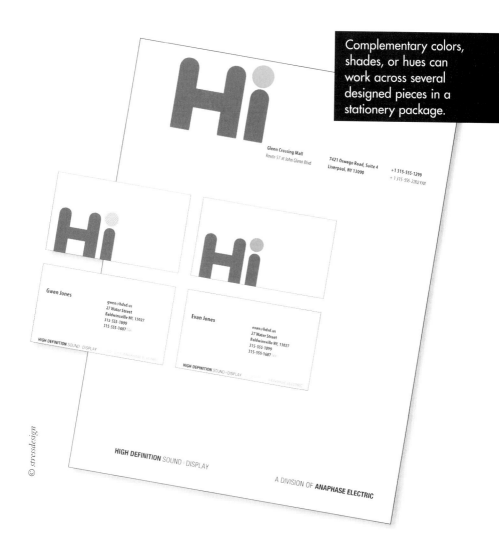

Complementary colors, shades, or hues can work across several designed pieces in a stationery package.

© *stressdesign*

Color

In addition to an image, such as a logo or mark, color can also serve as a unifying element. However, that doesn't mean the same exact color has to be repeated across all of the elements, just that they need to tie together.

The color(s) used on a stationery package should reflect the brand image and industry of the organization. But it also should be readable, which generally involves providing enough contrast between paper and ink color.

No matter how simple a design, if it is difficult to read the company's name or contact information, the design is ineffective.

Reverse Type

When designing a logo for a stationery package, create it in black-and-white to be sure the design can be reproduced well at its most basic state. Because if it looks great in black-and-white, you know it will look even better in color. The reverse is not always true, especially for typography; if you design everything in color first, you can end up with unreadable copy on your business card if you don't test it in black-and-white first.

Paper Choice

The choice of paper, as you read in Chapter 9, is an essential part of conveying a company's image. Paper can support a company's identity, or it can confuse it. Many law firms want to present a dignified and stable persona, for example. By using a cotton fiber or a heavier text weight paper with a good laid finish, the designer creates a visual identity linked with the logo or mark. On the other hand, using a lighter weight paper with a faux-marbleized effect would not be in keeping with the desired image the company wants to portray. The weight, look, and feel of paper create a tactile impression that either supports or confuses a company's image.

Weight

Without even looking at the design you've created, recipients of a company's or individual's business card can get a sense of the type of business they run simply by feeling their business card. The weight and thickness of a card can communicate a number of things, including these:

- Level of success
- Size of company
- Commitment to venture
- Professionalism

Whether you intend to or not, paper choice can convey a number of things about your design that may or may not jibe with the organization's desired image. A flimsy-weight card suggests it was printed in haste, or with a concern for cost. Similarly, purchasing perforated paper to produce your business card looks cheap and sends the wrong message about your company.

Finish

In addition to weight, whether the paper is coated or uncoated also can inadvertently convey an image. High-content rag paper, for example, may be perceived as more conservative and old-fashioned. That can be a good thing or bad, depending on your company's image and industry. This conservative image might be perfect for a fine English riding stable, but perhaps not quite so appropriate for a software-development boutique, where a slick, coated stock would be better suited. A cozy bed and break-fast would benefit from a down home, uncoated finish, whereas a national public speaker would want the photo and letterhead printed on glossy stock to reinforce a professional, slick image. Don't lose sight of who your client is as well as the client's audience. Select papers that reflect those needs.

Stationery

At the heart of a stationery package is the letterhead, or stationery, itself. In the United States, most letterhead is designed on 8.5×11-inch paper, although it doesn't have to be.

Paper Size

Although 8.5×11-inches is the standard, some companies opt for more off-beat—but more expensive—treatments as a means of standing out. Sometimes the look is more about functionality, too. Everything depends again on use, audience, and the message you want to present.

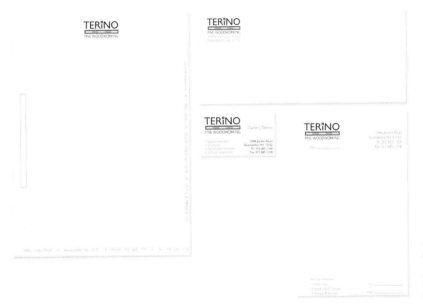

© Coburn Design

The letterhead here is a more traditional size, however, it isn't often used—On the other hand, the invoice is used most frequently, and it is much smaller than the letterhead.

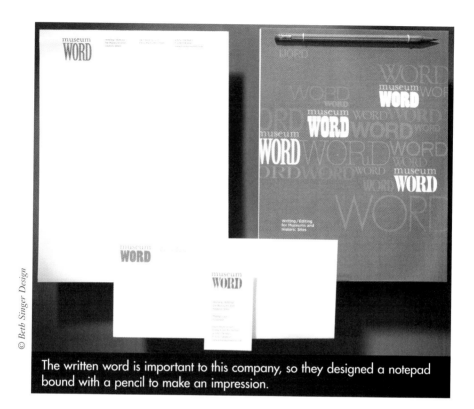

The written word is important to this company, so they designed a notepad bound with a pencil to make an impression.

Layout

There are a number of approaches to providing basic corporate information on stationery, from centering it to running it down the left or right-hand side of the page, placing it at the bottom, or some combination thereof.

It really doesn't matter where the contact information appears on the page as long as it is readable. Leaving it off or making it illegible does not constitute smart design.

Keep in mind that color bleeding off the page costs more because you print on larger paper and trim to 8.5×11-inches. Also don't forget to think about your audience; if you're business is targeted for an older demographic, conservative works. Designing for a young audience? Then bold color and sleek design are important.

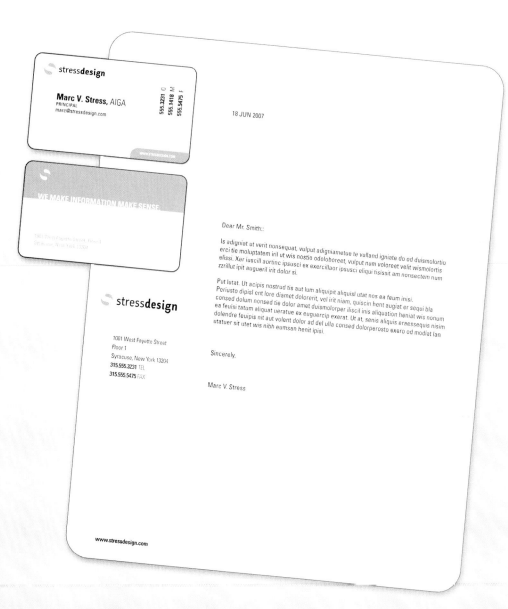

This company sets itself apart by die-cutting rounded corners into their business stationery pieces.

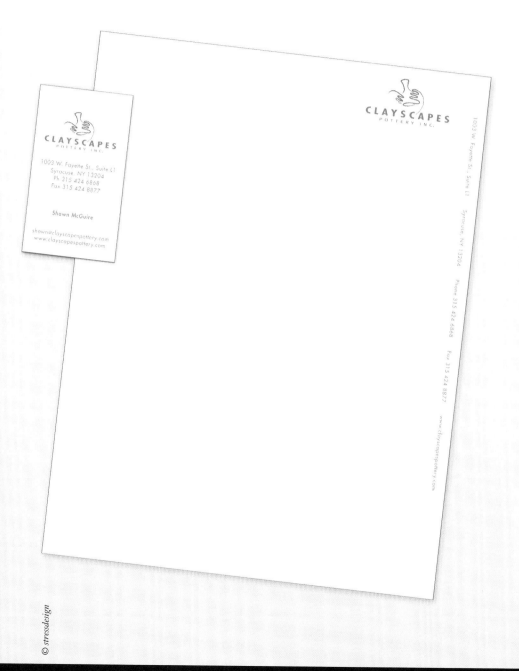

A vertical card design and contact information on the side of the letterhead makes this simple design stand out.

In addition to letterhead, some firms have a second sheet printed with the logo on it, or simply add the same paper with no printing as a blank second sheet for times when you need to send a letter or document with multiple pages. Complementary business, or #10 envelopes are the final piece for most stationery systems. Designs for envelopes should match the system, but also not place design elements in areas that conflict with the postal requirements. Refer to the mail specialist at your local branch or obtain the prepared templates for design use or check online.

Business Cards

While an argument could be made that letterhead is not essential for every type of organization, that same argument will not work for business cards. No matter what your age or occupation, business cards are a networking tool no one should be without. And the stronger the design, the more positively that reflects on the giver.

Dimensions

Most cards are designed on a 2×3½-inch rectangle; however, there is no law stating that cards must be that specific size. Designers always look for ways to design outside the conventional norms, so odd sizes and orientation are options that are often used.

This company printed both sides of their card, and used a rounded corner for the top.

The only real downside is that people who still use business card organizers may have difficulty storing an odd-shaped card.

© Coburn Design

Julia Allen
personal chef

à la carte

in-house catering [315] 555-2512 www.alacartechef.com

Format

Another option, besides designing a horizontal, 2×3½-inch rectangular business card, is to use the back of the card, or create a fold-over flap for additional space. Sometimes even doubling the size of a card and folding it in half fits the traditional size, but the fold and extra area for information makes for a different approach—and notice, every time!

Other formats are also possible, such as a flap across the front, or a z-fold.

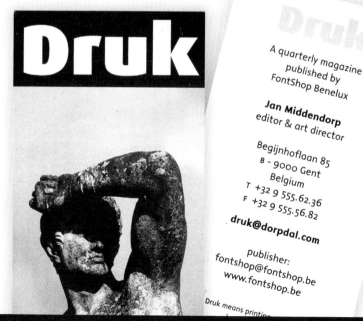

Image courtesy Jan Middendorp

Druk

A quarterly magazine published by FontShop Benelux

Jan Middendorp
editor & art director

Begijnhoflaan 85
B - 9000 Gent
Belgium
T +32 9 555.62.36
F +32 9 555.56.82
druk@dorpdal.com

publisher:
fontshop@fontshop.be
www.fontshop.be

Druk means printing

Why not make effective use of both sides of a business card?

A folded flap provides extra space for a logo or additional information, creating a near-flyer.

© Happy Creek Studio

The Least You Need to Know

- A corporate stationery package includes, at minimum, letterhead, matching envelopes, and business cards. To round out the package and present an even more pulled-together look, mailing labels, folders, large envelopes, stickers, and other marketing tools are worth considering.

- Pieces of a stationery package don't necessarily have to match exactly. Complementary images and colors can have just as much impact.

- The paper chosen can shape the effectiveness of a design as well. Designs produced on glossy, coated paper look very different from those printed on uncoated stock, just as pieces printed on heavier, cover-grade paper present a different image from those produced on 20-pound writing weight.

- Business cards are perhaps the most important business tool you'll design. While the most popular size is a 2×3½-inch horizontal format, you have the freedom to design it vertically, with printing on both sides, with a flap, or in a totally different size and shape.

Brochures

Brochures are among the most flexible, all-around useful marketing tools you will ever design. Whether you're a small business owner in need of a comprehensive promotional piece to describe what you do, a nonprofit announcing an upcoming fundraising opportunity, or a neighborhood association trying to rally the troops for a special clean-up day, a brochure can serve all of those purposes and more.

Although brochures come in myriad shapes and sizes, what they have in common is the purpose to inform. Using images, text, and color, brochures aim to give readers all the information they need to make a decision. Generally, that involves a purchase of some kind.

Along the way, you must make many decisions about format, look, color scheme, and information flow that impact a brochure's effectiveness.

Purpose

Before you get too far along in your brochure planning, step back and think about what you want your finished brochure to accomplish for you. Are you trying to drum up business for a particular brand or product? Trying to increase awareness for your organization? Aiming to educate potential customers about an important issue? Or something else?

The three general types of brochures are capabilities, promotional, and product catalog.

Capabilities

Very common in service businesses, a capabilities brochure is designed to present an overview of a company's expertise. Because there are no products to display, the look and feel of the brochure play an important part in *positioning* you to win a new client.

Positioning refers to how you want your target audience—your customers and prospects—to compare you to your competitors. Are you high-end? A bargain hunter's dream? Very tech savvy? Full-service? These are positions in the market that companies take, based on customer perception.

A capabilities brochure normally describes the types of services the company provides, the background of those providing it, what process or methods they use, and whether any specialized training or equipment is involved. After reviewing it, a potential customer should have a very good sense of the services the company offers, and feel confident in the skills of the company's employees. If that occurs, the brochure has done its job.

The design of the brochure plays an important role in a capabilities piece, by suggesting the company's personality through layout, photos and illustrations, typography, and color usage. Is it staid and strong, or creative and whimsical? Young and trendy, or mature and established? Your brochure design will suggest your company's personality before a single word is placed on the page.

Photos of projects, products, or satisfied clients in a capabilities brochure can serve as indirect, but very effective, testimonials.

Promotional

If your aim in producing a brochure is more short-term, more sales-oriented, then your purpose is promotional, not informational. The design and content need to shift accordingly.

Rather than trying to provide a lot of general information, a promotional brochure is very focused on one issue, product, event, or service. Its single goal is to get you to take action—now. Depending on your organization, that action might be to join a health club, take advantage of a limited-time offer, sample a new product, support a local charity, or consider installing new custom closet organizers.

A promotional brochure is limited in scope information-wise, but is even more eye-catching than a capabilities brochure. It has to be, in order to get you to notice it, read it, and take action. A capabilities piece is more of a reference, not a sales promotion.

Catalog

Catalogs listing a company's product offerings are a blend of a capabilities brochure and a promotional piece designed to spur sales.

They are broad in scope, often featuring a company's current product inventory, but with snippets of information about each individual item. Photos are essential, whether the catalog is for consumers, such as for clothing, gifts, or furniture, or for businesses, as with equipment, packing materials, or computers. Very few consumers buy a product without knowing what it looks like.

Other pieces of information that are critical in a catalog are pricing and product descriptions. This kind of information is sometimes found in a promotional brochure. Information on pricing or product features that require frequent updating, are sometimes printed on a separate sales sheet and inserted into the catalog.

Companies selling repair parts often rely on a catalog to show customers the wide variety of products they offer. But even non-profit organizations might use a catalog to list the many items up for bid in an upcoming charity auction.

Design on the Cheap

If you can't afford to print a 100-page glossy color catalog, not to mention updating it regularly as new products are added, consider a format other than a bound book. A three-ring binder is one less-expensive approach, because you can print up additional sheets as necessary. An online catalog is another option, as is a card pack, which contains 50+ individual index card–size promotional offers, all packed and mailed as one unit.

Audience

In designing a brochure, you want to think about who will be reading it and in what environment. That is, will your brochure be handed out to consumers—individuals who are making a purchase decision for themselves and their family—or to business professionals, who will likely be considering it on behalf of their company or employer?

Consumer

Brochures designed for consumers need to be eye-catching, and need to appeal to the specific needs and wants of that individual. It's all about that person's preferences and concerns about making the right choice for him- or herself.

Because you're attempting to connect with a particular person, let your design, your color choice, and your words reflect your organization's personality.

Business-to-Business

When designing a brochure for a company or organization, where several decision-makers are generally involved, you'll need to err on the side of being ultra-professional. That means staying away from cutesy, primitive, or unusual touches unless they reflect your company's brand image.

The primary purpose of your brochure is to communicate the features and benefits of your services or products, but it also needs to be designed for the intended audience. Do a "design audit" where you find out how your competition promotes themselves locally

and how businesses similar to yours, but out of your local market, promote themselves. Knowing how your competition looks helps you design something different.

When marketing your business's products or services to other businesses, you'll want to emphasize the benefit of doing business with your company. Where consumers may be more concerned with cost and features, businesses are often swayed by the additional revenue you can help them generate, or the degree to which you can help cut expenses, improve the quality of their product, or enhance customer or employee satisfaction, for example. With companies, you need to convey how you will improve how it operates.

Brochure Production

All the same design principles we talked about in the first part of the book still apply when designing brochures, but there are a few production issues specific to brochures that you'll want to be aware of.

Size

Brochures can come in virtually any shape or size. While 8.5×11 inches is a common paper size for business-to-business brochures, consumer brochures are often finished to a size that measures 8.5×3.67 inches when folded, and are designed to fit into a #10 envelope for easy mailing. As you're designing your brochure, you want to make sure you have enough space for all the copy you want to include, as well as any photos or illustrations. But if you can stick with standard paper sizes—namely, 8.5×11 inches, 8.5×14 inches, or 11×17 inches—you'll save money at the printer, because you won't have to pay to have it custom cut.

Paper

There are thousands of different types and weights of paper to choose from, but for brochures, you'll want to stick with card stock or smooth, heavy text-weight paper, and one rated as laser-printer friendly.

Quantity

Because the bulk of your commercial offset printing cost is in the setup of the printing press, and not in the actual production process, once the printer gets started, it costs so little to keep it going. So instead of trying to keep your brochure quantity to a minimum, estimate how many you may use in the next year or two and print that many.

Reverse Type

Unless you intend to have your brochure printed by a commercial printer with offset equipment, don't have your images go to the edge of the page—called a bleed. Bleeds are high impact, but the printing technique requires you print on a larger sheet of paper and then trim it to size. That's hard to do accurately on an office printer and have it turn out well.

Printer

Sure, you can print your brochure on your office color laser printer, or even on a desk jet, and it will cost you little up front; however, the cost per piece will be higher than you expect, and the colors will not be quite as rich or as clear as a commercial printer can provide. Not to mention the cost of your time.

If you need fewer than 1,000 brochures, your best bet will usually be a local copy shop. The quality will be better than you can achieve on your printer, and you won't have to stand there and run them off.

For quantities between 1,000 and 5,000, a quick printer is an excellent option. These companies, with franchises such as Minuteman Press, Sir Speedy, and American Speedy Printers, have smaller offset printing presses and can print moderate-size quantities for a reasonable price.

More than 5,000 pieces, however, and you really need the help of a higher-end commercial printer. These printers can crank out huge quantities quickly, on virtually any type of paper, as well as provide added specialty treatments, such as *foil-stamping* or *embossing*, or trimming or *scoring* brochures.

Format

Any printed document designed to inform the recipient about an organization, product, or service, can loosely be termed a brochure. Within that general format, there are several variations, however, depending on whether a single piece of paper is used, or if several are stapled together or inserted within a folder.

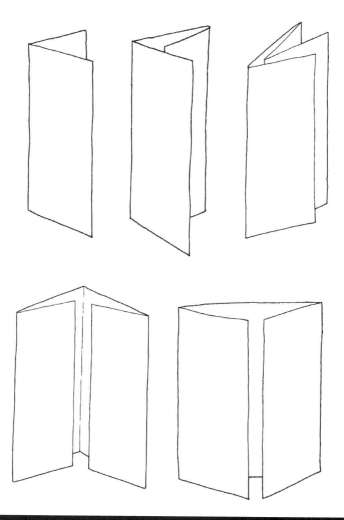

The variety of folds one can use for brochures. Left to right: bi-fold, tri-fold, two parallel fold, double gate-fold, single gate-fold.

Bi-Fold

A bi-fold brochure, while suggesting two folds, is actually a single sheet of paper with one fold in the middle.

It is best used for short announcements, event invitations, promotional offers, or teaser information about a recent success story or upcoming opportunity. With a total of four small panels, there isn't much space for copy, but there is still plenty you can highlight visually with a bi-fold.

© Coburn Design, Inc.

With long, thin pages, this bi-fold brochure is certainly anything but simplistic.

Tri-Fold

The majority of tri-fold brochures are produced on 8.5×11-inch sheets of paper, so that they can fit snugly in a #10 envelope. Very popular among smaller businesses, tri-folds offer six panels to present service offerings, product listings, or other information.

When preparing a layout for a tri-fold brochure, remember that all panels are not created equal. There will be two wide panels and one narrow panel. Wide panels each measure 3.7295 inches wide, and the narrow panel measures 3.6041 inches wide. Make sure you adjust the copy so that it fits both the width and placement needs for each panel. Also don't forget to allow for folds.

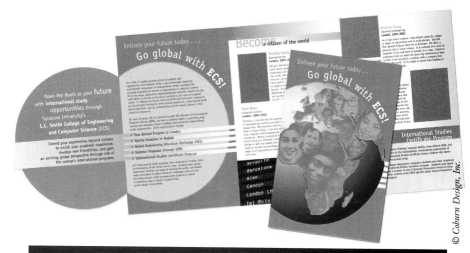

© *Coburn Design, Inc.*

Even a very traditional tri-fold brochure can become innovative with creative use of flaps and die-cuts.

Don't limit yourself, though. Tri-folds can be designed on any size paper, making them popular and adaptable.

Four-Fold

Generally designed on legal-size paper—8.5×14 inches—a four-fold brochure provides two more panels for information. They're a step up from tri-folds because they are slightly heavier and longer.

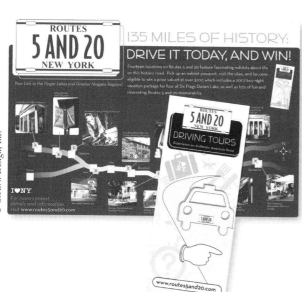

© *Coburn Design, Inc.*

Some brochures simply require more space, such as this foldout map for a section of New York State.

Accordion Fold

An accordion fold can be a versatile and innovative approach to brochure design. Easily adapted for use with an 8.5×11-inch sheet, an accordion fold creates more of a three-panel, z-shaped fold. Be aware, accordion folds require the same precise measuring as a tri-fold.

Clever use of graduated folds gives this accordion-fold brochure tabs without any staples or binding.

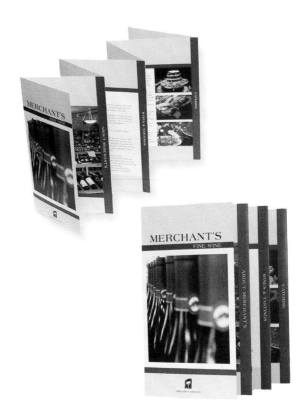

© ASG Renaissance

Gate-Fold

Gate-fold brochures are most commonly used for announcements and invitations, where the recipient peels open the front of the brochure, much like opening front doors. The biggest difference with gate-folds is that you use up two panels for the front, rather than one.

Another variation on the gate-fold is to use it like a book, by folding it one more time so the gate is on the inside. The folded

brochure looks more like a bi-fold when closed, but once it is opened, there are two more panels to open again, revealing more information.

Stackable Sheets

Some businesses fear making a major investment in a full-color brochure, only to have it be out of date in a matter of weeks or months. That's a risk you take, but there are ways around that challenge.

One solution is to use a pocket folder, either one- or two-sided, to contain a series of stackable cards or sheets. Each sheet is labeled to identify a particular brand, product line, service, or step in a process. When set one on top of the other, each sheet can be printed individually, so that updating one sheet does not require the entire brochure to be reprinted. Many companies print the stacked sheets in-house for speed and convenience.

When information needs to be updated regularly, individually printed sheets placed in a pocket folder can be very economical.

Individual Cards

Sometimes all that is needed in a brochure is a simple listing of services or contact information. Use a single 8.5×11-inch sheet of paper and divide it equally into three columns.

By placing the same information in each column, printing and cutting equally, you've created a *three-up layout* for the single card, thereby getting three times the cards from one sheet and from using both front and back sides to place information. This design saves you money by getting more out of each sheet, while still fitting into a #10 envelope.

© Roskelly, Inc.

Just because you have many products to display doesn't mean you have to present them in a standard square book—individual cards connected by a grommet work equally well.

The Least You Need to Know

- Before you start designing, think through what you want people to think or do once they've reviewed your brochure.

- Tri-fold brochures, with two folds and three panels, are the most common brochures used.

- If you expect to update your brochure fairly quickly, consider using a folder with insert sheets, which you can update and print in-house as needed.

- If you'll be printing fewer than 1,000 brochures, talk to a local copy shop; between 1,000 and 5,000, check with a quick printer; and more than 5,000 copies, you'll want a full-service commercial printer to help.

IN THIS CHAPTER

- Basic publicity tools

- Reusing existing materials

- Newsletter do's and don'ts

- Going beyond simple blog layouts

Public Relations Materials

Every organization, whether a Fortune 100 corporation, small business, nonprofit organization, healthcare agency, or school, should have a selection of public relations (PR) materials at-the-ready to take advantage of every opportunity to market itself that comes up.

PR materials are most frequently used to inform and alert members of the media to news about your organization; however, well-designed information packets and special events can also be effective tools for attracting new customers, suppliers, advisors, volunteers, or whoever your target audience is.

Fortunately, while there are a number of different types of PR tools, there are only a handful of designed pieces you might need. What they all have in common is that they help market your organization in a positive way.

Information Kit/Folder

An information kit, which is contained within a pocket folder, can provide an overview of a business or an important announcement, complete with relevant background materials.

Here are the key pieces of an information kit:

- A pocket folder
- One or more press releases
- One or more backgrounders
- Business card
- Photos of products, people, or a portfolio of work

At the core of an information kit is a press release, one of the most-used PR tools. A press release is a one- to three-page document that announces something newsworthy. That could be a new product debut, a new employee, an award, an important medical breakthrough, results of a recent study, or the start of a new business.

Although they are placed in the front of an information kit, press releases can also be sent out on their own as standalone documents.

Most organizations simply print out their press releases on plain letterhead using the standard press-release format, but larger companies might design special press materials to use solely for such announcements.

Unless your organization is a start-up, you will already have access to stationery and business cards, onto which you can print the press releases and background material. The most important part of the information kit is the information inside, so don't overspend designing unique folders that may not improve the kit's results.

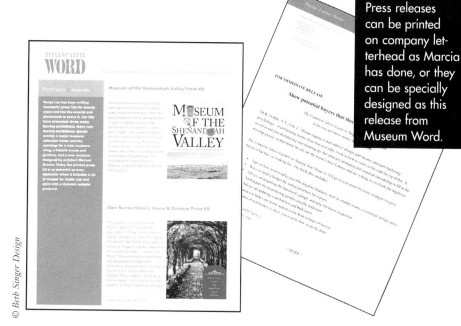

Press releases can be printed on company letterhead as Marcia has done, or they can be specially designed as this release from Museum Word.

Portfolios

Designers and artists are familiar with the large black portfolios they use when making presentations of their work. However, in this case we're specifically referring to the way you present your work when you cannot physically be present to show your large black case—the examples to include in the information kit.

Including a CD burned with the digital version of your portfolio is one way to distribute samples of work. Creating a *PDF (Portable Document Format)* file of your portfolio makes sure anyone with a computer and a free copy of Adobe Acrobat Reader downloaded on their desktop can view your samples. Don't forget about the actual disk or the jewel case used to hold the disk. These are prime areas to place some identifying information, and they should reflect your design skills as well.

A good idea is to also include print representations of your portfolio in the information kit. It might seem like overkill, but having both the CD and the paper representation of your work provides more options to the end-user. It enables the viewer to share with

other reviewers, see the highest resolution image by referring to the CD, or to quickly determine whether or not to keep looking further at your package. Here's another opportunity for you to showcase your design skills, make sure the paper samples of your portfolio are well designed, and work with the entire contents of the information kit.

This information kit is for a high-end property and is designed to reflect a specific look and perceived value to potential investors.

Most information kits are contained within store-bought folders and in-house printed labels.

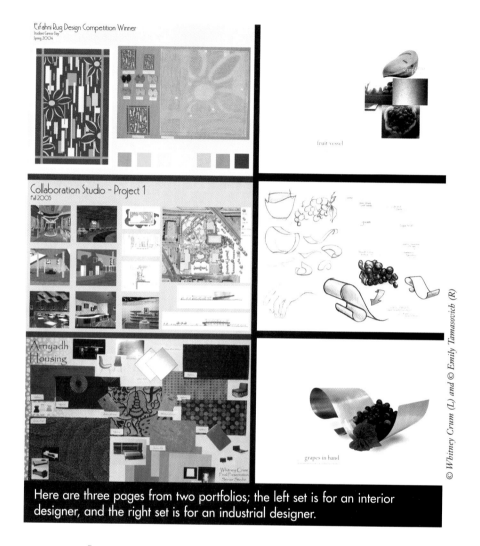

Esfahni Rug Design Competition Winner
Student Green Day
Spring 2004

fruit vessel

Collaboration Studio - Project 1
Fall 2005

Amyadh
Housing

Whitney Crum
Final Presentation
Senior Studio

grapes in hand

© Whitney Crum (L) and © Emily Tamasovich (R)

Here are three pages from two portfolios; the left set is for an interior designer, and the right set is for an industrial designer.

Newsletters

One of the most popular PR tools around today is the newsletter. We talk about the new electronic version in a minute, but print newsletters are still very much in style.

Newsletters can be used to keep in touch with external audiences, such as customers, prospects, and referral sources, or with internal audiences, such as employees, volunteers, and suppliers.

Newsletters are a very popular means of communicating with constituents, whether they are customers, patients, suppliers, or prospects.

Most newsletters are two pages—one 8.5×11" sheet of paper, front and back—or four pages—one 11×17" sheet of paper folded in half. But you can certainly have more pages—enclosed additional sheets or stapled together. Choose your size based on your printing and mailing budget and the amount of information you have to share.

Some industries have newsletter services that, for a fee, will place the company's name and logo on the masthead as the sponsor, and distribute it to the business's mailing list. The service prepares the entire newsletter, thereby reducing the company's involvement. If you know your company does not have the time to design, write, print, and mail its own newsletter on a regular basis, consider paying a newsletter service to handle this job for you. Real estate firms, insurance brokers, financial planning firms, and dental offices are frequent users of these services, which create industry-based content that can be customized with company names and information.

© Beth Singer Design

Keeping employees in the loop is critical for organizational effectiveness.

The best newsletters reflect their readers' interests, and provide news and helpful tips their customers or employees would value. Good designs are easy to follow and should help the information to flow well. Using graphic devices such as pull-quotes, mastheads, and signs adds variety to a layout. Creating consistent headline treatments, following a well-crafted grid system with plenty of white space will set your newsletter apart. The overall look and feel should mirror or complement other marketing pieces the business has created.

Creative License

Rather than having to create a newsletter several times a year, decide to design and produce two issues at a time, so you only have to work on it two times a year if it's quarterly, or six times if it's monthly, versus four and 12 times, respectively. You'll save time and printing costs by effectively cutting your print runs in half.

E-Zine

Since the mid-2000s, print newsletters have been taking to the Internet. That is, they've gone electronic in the form of the e-zine, or electronic newsletter.

To compete with the amount of e-mail we all get, e-zines need to be eye-catching and easy to read. Here is an e-zine that Marcia writes, and one that is a text-only format.

Marketers agree that keeping in touch with customers and employees is smart, but whether that information comes via the U.S. mail or e-mail doesn't seem to matter much, if it's well designed.

E-zines have the same goals and objectives as print newsletters; they're simply designed and distributed without the need for printing.

Because they are designed to be read onscreen, they are generally much shorter than print versions, so readers don't have to scroll down too much. When the readers have to scroll in order to read more, they generally won't continue reading.

So that readers associate your organization with the e-zine that arrives in their inbox, follow the same design approach as you would with a brochure or flyer: use corporate colors, a logo, typefaces that complement the logo and are easy to read, and photos or illustrations that match the organization's image.

Once you've created a design you like, use it as a template so that subsequent issues look similar. If you're having trouble creating your own, you can choose from many options available through e-mail marketing companies—you simply paste in the copy you want.

Blog

Another hot marketing tool these days are *blogs*, short for web log.

Blogs have become a popular way for individuals and companies alike to share their thoughts and perspectives on various subjects. Many major companies have a member of their staff who is the designated blogger, and who is responsible for regularly uploading commentary.

Each blog is like a single web page, with multiple entries, photos, streaming video, and copy. And while most bloggers use simple templates available through the blogging companies, you can certainly create your own, more exciting design.

Using major blogging services like blogger.com or wordpress.com, you can create an account, select your background template and colors, and begin typing in a matter of minutes. Or, you can design your own page layout and upload that, reinforcing your own brand image and identity.

You can also choose a hybrid option, by downloading a free blog template and then modifying it for your own use. You'll save time by not starting from scratch, while still achieving a standout look.

© June Sylvester Wales

The focus of blogs is the information they provide and not the appearance, although the more professional the appearance, the more authoritative the copy sounds.

As blogs become an even more popular source of information, you'll want to make sure your blog's design reflects your organization's image as well as its message. Investigating costs for custom-designed blogs or blog templates makes changing your look easy. And if computer programming is a hobby, using scripts that are available is another way to start.

Because blog systems like Wordpress and Blogger provide built-in templates, most blogs today look strikingly similar. With your help, however, we should start to see more variety of blog designs in the coming years.

Modifying a free template can be a great, cheap alternative, too.

The Least You Need to Know

- You don't need to design an entirely new set of public relations materials: most companies simply print news on existing letterhead.

- Newsletters are extremely effective means of staying in touch with customers and employees. While print versions are very popular, designing and distributing an electronic newsletter—called an e-zine—can be more cost effective and faster to produce.

- Although sharing information, including opinions and perspectives, is the sole purpose of a blog, what the page layout looks like affects how the information itself is perceived. The better the design, the more respected the copy.

- Online services to create and distribute e-zines and blogs are relatively inexpensive, and they offer free templates to speed the process along. You can be publishing an electronic newsletter or blog in a matter of minutes using these services.

IN THIS CHAPTER

- Postcard production tips

- Benefits of bill stuffers

- Flyer facts and uses

- Catalog design basics

CHAPTER 21

Direct Mail

Direct mail is the mail everyone loves to hate. Yet it works. That means despite all the complaints about unwanted cards, letters, flyers, and brochures, most people still respond to well-designed direct-mail pieces.

Although direct-mail campaigns can be quite costly, there are plenty of alternative approaches that won't break the bank and will still yield a solid return when done well. That's where we're going to focus.

Postcards

Postcards are effective because of their format—you don't have to open an envelope to get the gist of the message. Most people will flip a card over to at least glance at both sides, and within those few seconds, you've achieved your objective. They took a look at it and considered the information.

Reverse Type

Although it may cost far less to send direct mailings bulk rate, be aware that many corporations now routinely discard all bulk mail that is delivered. So if you're marketing business-to-business, you'll want to stick with first class to improve the odds that your piece gets to your target's hands. Otherwise, it will probably simply get tossed.

While postcards are cost effective, sending a lone mailing is unlikely to reap any rewards. You really need to send a series of postcards to increase the odds that recipients will read the information and act on it. Studies indicate that it takes six or seven impressions of, or contacts with, an ad or promotional message before it sinks in. Until then—when your sixth or seventh postcard arrives—your target customer isn't making any kind of purchase decision.

Customers may start to look forward to your monthly postcard if you send it out regularly.

© Northeast Dental & Medical Supplies, Inc.

A series of post-cards, sent at regular intervals, is even more effective than just one or two sent at random times.

If you have an ongoing need to stay in touch with customers, such as to announce a weekly or monthly event or sale, postcards are the perfect tool. You have just enough space to provide the information on the card, without incurring huge costs for printing and mailing.

Before you initiate a large mailing, do a test run. Mail yourself a few cards, and see what condition they are in when they arrive on your doorstep. You may find that the paper weight you selected isn't robust enough, or that you designed the address in the wrong location on the card—all good things to know before you spend money on postage for thousands more.

Don't forget to get another set of eyes to review your work before sending. When you work with a design for several edit rounds, you're not as objective. Have someone else read it and look for typos and missing information. The hardest thing to accept is forgetting to put a time or place on a card or making a glaring misspelling.

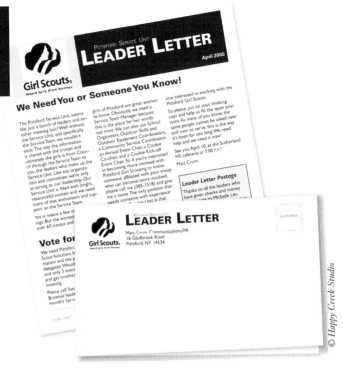

The simplest self-mailer uses a standard-size sheet folded once or twice.

© *Happy Creek Studio*

Self-Mailers

Design on the Cheap

To save money on mailing costs, do some of your own pre-sorting, grouping like zip codes together; this will save you pennies on every piece. Ask your post office for guidelines on how you should sort before you start.

A postcard is a rectangle no larger than 4×6″ (and if it's larger, you get charged first-class postage), while a self-mailer is a single sheet of paper folded and held together with a *wafer seal*.

The advantages of a self-mailer, which refers to the fact that the information is not enclosed in an envelope, is that it can be virtually any size, as long as the fold is along the bottom edge.

Although self-mailers avoid the use and cost of an envelope, there is still the curiosity factor—recipients of self-mailers unfold them to see what they're about. Done well, the outside of a self-mailer teases the recipient regarding what is inside. Using a provocative image or a leading question entices the viewer to look inside. That is why they're opened.

While more costly, using larger cards or pieces of paper for your direct mailings does give you more space to talk about sales, services, or products, or to add more images. If you have a high priced or complex offering, you may get better results by featuring more benefits right up front. To do that simply requires more real estate.

One advantage of this self-mailer is the use of a larger-size sheet of paper.

Commenta

FAIRPORT EDUCATION

Vol. 45 No. 1 www.fairport.org

A News Publication from the Fairport Central School District Winter 2007

Board Adopts Direction for Year

At the January Board of Education meeting, members completed the discussion of their annual goals and adopted them. President Matthew DiRisio noted that "We have been moving forward, and now the adoption of the goals solidifies our direction for the remainder of the year." The goals focus on student achievement, facilities, collaboration, and budget building.

1 | Recruit an outstanding Superintendent of Schools

Desired Result: To hire a tested, dynamic, humane Superintendent of Schools by Nov. 1

Result: Jon Hunter, Ed.D., was appointed and took office on Nov. 15

Strategies for Implementation

* Utilized an external, experienced consultant who coordinated and monitored the search process
* Gathered stakeholder input through focus groups
* Provided a survey on the District website for community; provided a paper survey at the District Office for those lacking computer access
* Targeted sitting superintendents with demonstrated proven records of success and achievement and invited them to apply
* Conducted thorough search process, extensive reference checks, phone conversations, and in-depth personal interviews with the top candidates

2 | Create and implement a comprehensive superintendent evaluation process

Desired Result: An open, shared evaluation process that will improve performance of the Superintendent and the Board

Strategies for Implementation

* Conduct goal-setting sessions involving the Board and Superintendent with sessions being a shared responsibility
* Use a process that is inclusive in identifying all areas that the Superintendent will be evaluated on

continued, page 3

Senior Earns Perfect Scores on ACT, Math SAT

Christopher Kauffman was the only student in New York state to achieve a perfect score of 36 on the ACT (college admission and placement exam). He was one of only 75 in the nation to score that well on the ACT, which was taken by 475,000 students.

Christopher Kauffman

The ACT measures students' abilities in English, math, reading, and science. Each area is scored on a scale from one to 36, and then the scores are averaged to come up with a composite.

In addition, he earned a perfect 800 on the math section of the SAT which colleges use as part of their admissions process. His overall score on the SAT was 1570 out of 1600.

Math has been an integral part of his high school activities such as Math League and Science Olympiad. At the same time, he plays trombone with the Concert Band and Jazz Ensemble. He's also involved in scouting and last year achieved the rank of Eagle Scout.

Christopher is considering four colleges where he will pursue, not surprisingly, a career in math. The schools are the University of Rochester, Massachusetts Institute of Technology, the University of Michigan, and California Institute of Technology.

Reflections Published . . . These FHS students were guests at the press party at Rooney's Restaurant for the unveiling of the coffee-table anthology titled Susan B and Me. Through poetry or prose, they contributed their reflections on the female experience which were included as part of the book dedicated to the spirit of Susan B. Anthony. The young writers are (l-r) Chelsea Miles, Alison Hajemius, Caitlin Cordona, Rachel Martin, and Brittany Lewis. English teacher Kimberly Kearney was an associate editor on the project developed by Fairport resident Patricia Ronzuille.

NEWS FROM FAIRPORT SCHOOLS

Commentator

38 West Church Street Fairport, New York 14450

Board of Education
Matthew DiRisio, *President*
Joyce Kostyk, *Vice President*
Christine Heisman
Jeanne Kremers
Thomas McJury
Maureen Nupp
Terri Pries

Superintendent of Schools
Jon Hunter, Ed.D.

Editor
Mary Jane Yanner

Design
Nancy Thomas

ECRWSS
POSTAL PATRON

U.S. Postage
PAID
Permit No. 74
Fairport, N.Y.
Non-Profit Org.

Bill Stuffers

One great way to reduce your direct-mail costs is to piggyback on another mailing going out, such as a monthly bill. Promotional materials that fit neatly into a #10 envelope and are accompanied by a bill are called bill stuffers.

Creative License

Because most bills are printed on uncoated paper, if you print your bill stuffer on glossy paper, it will stand out against the bill, without adding extra weight.

While there is a cost to design, print, and insert such promotional pieces, they can be extremely effective, because you know there's an excellent chance the recipient will open the envelope to retrieve her bill. And while she's unfolding the invoice, she might catch a glimpse of that great deal you're offering on the enclosed flyer.

Using a lighter weight paper allows for an 8.5×11-inch sheet to be folded to fit a #10 envelope. You can also make the same size sheet a three-up layout and cut into thirds after printing to include in invoices. Printing on a legal size sheet and folding it twice fits a business envelope, too, although mailing that size sheet requires more postage.

Bill stuffers are becoming a common way to get special offers into consumers' hands.

NORTHEAST
Dental & Medical Supplies, Inc.

Moving Your Practice In the Right Direction!

Dr. NEDS
Handpiece Lubricant

Dr. NEDS
Handpiece
Lubricant

1oz. Bottle $11.50
3+ $9.95
Buy 3, Get 1 FREE

Easy to use for both high- and low-speed handpieces. Three drops are all you need. Simply put the drops

© Northeast Dental & Medical Supplies, Inc.

Flyers

"Flyer" is a generic term for a multifunctional promotional tool. While a flyer is generally a single 8.5×11-inch piece of paper that is printed on one side, it can be unfolded to serve as a poster placed on a bulletin board, or folded and mailed as a brochure.

The biggest advantages flyers offer are that they are relatively quick and easy to design, and less expensive to produce.

Flyers can also be inserted into newspapers as advertisements, enclosed with bills as bill stuffers, handed out at events, or placed on retail counters.

Flyers can be used to announce an upcoming event, promote a special offer, or garner support for a community concern.

The most effective flyers are devoted to one company, product, event, or special offer, rather than trying to serve as a capabilities piece or catalog. In general, a single image is best, rather than a

collage or series because recipients may only glance at them casually after receiving them. Just as you design billboards to take into account the fact that viewers will drive by at high speeds, you need to be aware that flyers are often only scanned. You need to catch their attention with a bold graphic and large headline.

After the large headline and image, you'll want to be sure you hit the high points of your message. If you're announcing an event, you'll want to make the date, time, place, and cost stand out. If it's a sale you're promoting, listing brand names that will be available, or special promotional pricing, would be attention-getting.

Above all else, however, keep it simple.

Catalogs

Pieces that are designed to market a broad selection of products are generally called catalogs, although they can be any length or size. From clothing to toys, furniture, parts, or college courses, catalogs aim to give recipients a good sense of what the organization has to offer.

While expensive to produce because of the number of pages—anywhere from eight to several hundred—catalogs can also serve as reference guides, which have a longer lifespan than most promotional tools.

Catalogs exist for products ranging from cars to clothing to plants, sports equipment, and even cigars. Intricate industrial parts catalogs contain useful indexes and other resources. High-end specialty clothing catalogs make use of white space to show off the products in use. Some catalogs are designed using a theme—these can be seasonal or focused on specific activities such as camping.

Catalog design varies by placing images of products and descriptions in different layouts, but all use a grid to organize the information. Some use graphic elements such as lines to separate information. The most effective catalogs are designed to be easy for customers to find exactly what they are searching for without much effort, using photographs that present the products in their most positive light.

Many catalogs are printed on glossy paper, featuring photos of the products being described within. However, glossy paper and color photos are not required; some catalogs, such as for auto parts, are effective printed on uncoated stock with line drawings.

The first catalog ever created was by Sears Roebuck & Co., which sold everything from homes to tools. This home products catalog continues the tradition today.

Besides the printing cost, binding is another consideration. The three general types of bindings used for catalogs and booklets are these:

- Coil Wire-bound—When you want your catalog to be used as a reference or to lie flat on a counter or desk, wire binding is best. This term applies to spiral bindings made of plastic coil as well, that wrap around perforations along the left edge of each page.

- Saddle-stitched (stapled)—This is best used when there are only a few pages, since the sheets cannot lie flat.

Comprehensive catalogs may be kept on hand, rather than promptly discarded.

- Comb-bound—Similar to wire-bound but not as durable or as easy to turn the pages. Comb binding uses a plastic curved comb to connect several sheets of paper, and needs a machine to perform the binding process. Different size combs, based on the number of pages to be bound, are available, although this type of binding is not recommended for books larger than two inches in thickness.

- Perfect-bound—Much like a book, this is best for catalogs of 100-plus pages.

Use, length, and budget will help determine which type of binding is best, (left to right) wire, saddle-stitch, comb, or perfect bindings.

The Least You Need to Know

- Postcards are inexpensive promotional tools that can be very effective for announcing an upcoming event or special promotion; however, a single postcard mailing is rarely effective—a series of postcards designed around a theme or message performs better.

- Self-mailers, which can be folded several times and sealed, provide flexibility of size and reduced cost due to elimination of the need for an envelope. The only downside is the possibility that the piece won't arrive in the best condition. Test a few before moving ahead full-steam.

- An economical way to send out flyers is to pay to enclose them in another organization's bills, called bill stuffers. You design and print a flyer to fit inside a #10 envelope; you pay for insertion, and the company pays the postage. Not a bad deal!

- Flyers can be used as brochures, posters, special-announcement mailers, or event invitations, among other things. They are versatile and relatively inexpensive, although the standard size is 8.5×11-inch, folded twice.

- Catalogs are designed to sell products—everything from clothing to printer ink to car parts—and feature descriptions and images of the products. Some are designed to spur an immediate purchase, while others are produced to be more of an ongoing reference guide.

- Choosing effective giveaways

- Creating paper promotions

- Combining design and function

- Dealing with design challenges

CHAPTER 22

Promotional Tools

While graphic designers primarily create on paper, thinking beyond traditional documents and tools can yield innovative and highly effective promotional tools. All organizations—whether they are corporations, start-up companies, nonprofits, or educational institutions—have a need to spread the word about their products and services. And sometimes that entails placing the word on less conventional media.

After you've designed the basics, such as business cards, letterhead, and a website, you might look for more unusual promotional items to create. There are plenty of paper tools, such as notepads, sticky notes, and coupons, as well as more functional fare, such as ceramic mugs, t-shirts, coasters, mouse pads, and more.

Think fun giveaways, and then start looking for ways to incorporate your company's logo or brand.

Paper-Based Promotions

If your budget is, shall we say, constrained, but you need a give-away besides a business card, stick with something you can design and print on paper. In most cases, you can come up with a jazzy design you can produce quickly for a reasonable price.

Notepads

Notepads are excellent promo items because you can hand them out to clients who come into your office for a meeting, you can distribute them at conferences and trade shows, and you can pass them out at the register—the opportunities are endless. Most important, however, is that everyone can always use a pad of paper to take notes on.

This notepad reinforces the company's work with wood by the ink colors used.

Screening an image or copy refers to reducing the intensity of the ink from 100 percent down to 60 or 50 percent, or less. So instead of black, for example, you'd see charcoal or light gray.

Although notepads can certainly come in any size, the standard 8.5×11-inch size is easiest to design for, and less expensive to print on because the paper needs no trimming.

No matter what size paper you're designing for, you'll want to make sure the recipient has plenty of blank space to write in. Completely obliterating the

paper with a corporate logo or message makes it unusable and a waste of time.

A better approach is to go subtle, perhaps using a *screened* image rather than full-color.

Or, another approach is to leave any printed information on the side of the page.

You are certainly not limited to standard writing-size paper, however. You can create blocks of notepaper, pads of Monarch-size sheets, or anything smaller or larger that you think your audience will appreciate.

Don't cover the writing space with images and illustrations that will make the pad unusable.

Providing handy info while still allowing note space is an effective design combination.

Sticky Notes

Another form of notepads is adhesive-backed stacks of paper, which are generally smaller in size but are popular business tools.

As marketing tools, sticky notes are a smart option because your corporate identity can be passed along well beyond the original recipient. That is, you may hand out sticky notes with your logo on it at a trade show, but then anyone who receives and uses them will be helping to alert others to your business name and offerings.

Coupons/Promotions

Another tool with high pass-along value are coupons and special promotions. Typically designed on paper, money-saving coupons, special offers, or limited-time promotions are a way to generate interest in your company.

Coupons can be mailed out to customers, printed as advertisements, placed in shopping bags, or handed out at the place of business. How they'll be distributed will affect how you design it, to keep your costs reasonable without reducing the impact. For example, if you're mailing a coupon, you want to make sure you don't exceed the post office's maximum size dimensions or you'll be charged more postage. But if you're handing them out, you could use an 8.5×11-inch sheet of paper to its fullest.

Encouraging customers to frequent your business can be as simple as tracking their purchases as part of a rewards program.

Increasingly, retailers and restaurateurs are creating frequent-buyer programs that track customer purchases and reward them when a certain threshold has been met, such as an amount spent or number of return visits. Frequent-buyer cards can be designed on a business-card-size card stock, and then laminated for durability, if that's a concern.

Nonpaper Tactics

Depending on your type of business, you may also find a need to have gifts or giveaways on hand for prospects and customers. More durable products with your organization's name on it are popular items that designers are often called to assist with.

Mugs

One of the most popular giveaways are ceramic mugs, because they can be made available to business visitors, who are then permitted to take them home.

Some companies have mugs designed with their logo, product, or event information, and then distribute them with other goodies, such as candy or coffee packets.

But mugs aren't the only type of item available; you can find a plethora of glasses, cups, and water bottles, and many other items on which to feature your company's information. Always check with the production department of any printer, local or online, for their guidelines. Many give you "live" area sizing—the dimensions of the space you can fill with your design—so you know what your limitations may be.

The only challenge with curved surfaces, as you have with mugs and glasses, for example, is that you may want to alter your design so that it is totally visible from the front. Horizontal or wide designs will have a tendency to bleed off the sides, where the edges may not be visible without turning the glass.

T-shirts

Wearable promotions are also very effective, especially for special events, such as nonprofit walks, running races, or trade shows. T-shirts are the most popular choice of clothing, but companies can certainly opt for sweatshirts, sweatpants, shorts, polo shorts, windbreakers, hats, scarves, or virtually anything else you can think of.

T-shirts are often chosen because they are among the lowest-cost clothing options. Craft stores are a great source of inexpensive shirts, believe it or not.

The process of transferring a design to fabric is the same whether you're producing t-shirts or messenger bags, handbags or scarves. If you're attempting to do it yourself, carefully read instructions that come with your printer or the materials used in a printer for

© tmarksdesign

This design firm put their mark on these messenger bags for their clients.

guidelines. In most cases, you'll print out your design in reverse (which is an option in most design programs) onto photo transfer paper. Then you put the design face down onto the t-shirt and iron it according to the instructions, peeling back the paper once the design is adhered.

Reverse Type

If your t-shirt design has words in it, you'll want to first print out the design in reverse, so that when it is ironed on the shirt the message won't be backward.

If you're hiring out the service, check with the production department for specifications and guidelines. There will be different considerations to consider based on size, process, and colors.

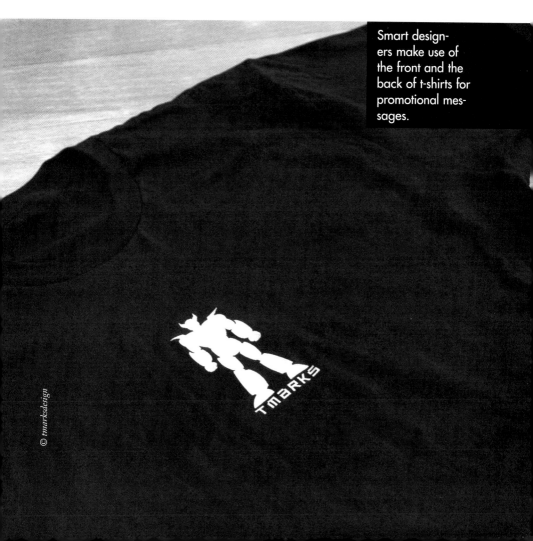

Smart designers make use of the front and the back of t-shirts for promotional messages.

© tmarksdesign

Creative License

To get a sense of the wide variety of promotional tools out there, do an online search for "ad specialties," or check in your Yellow Pages for local ad-specialty companies. They should be willing to send you, or let you borrow, large catalogs of promotional products.

Coasters and Mouse Pads

Depending on your audience, you can find promotional products to fit almost any age range, gender, or use. For a techie audience, a wireless mouse or mouse pad are good choices. There are companies, locally and online, that specialize in these types of products.

Regardless of the size you have to work with, the same principles and elements of design apply. Grids and layout are used and the process is not really different than that used for creating print, production limitations are more equipment-based. Good design can work anywhere.

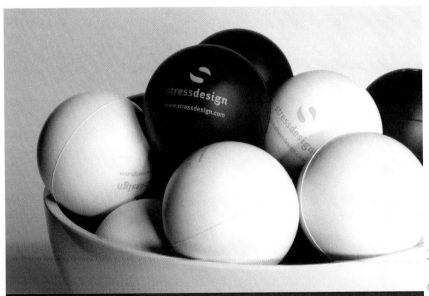

© stressdesign

Don't limit your thinking simply to clothing when looking for places to feature your designs. This design firm used these stress balls to play on words with their own name.

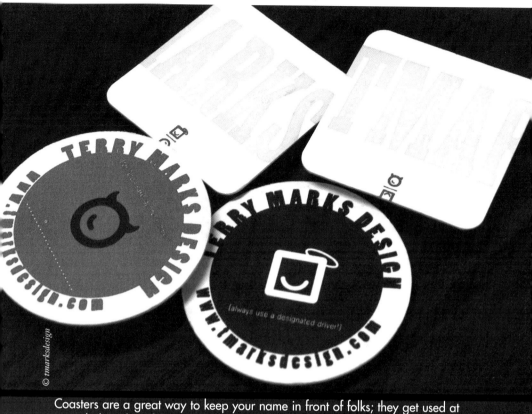

© *tmarksdesign*

Coasters are a great way to keep your name in front of folks; they get used at your desk and conference rooms.

For some promotional products, you may able to do a better job, and use higher-quality products, if you do it yourself. Take coasters, for example. You can buy very nice glass coasters with an inset for an image in the center for only a few dollars. Fill it with your design(s) and you have a very nice giveaway—whether you need 1 or 100. You can control the quality of the merchandise and output when you do it yourself; however, the larger the quantity of promotional items you need, the more time it will take, and the more likely it is that you'll want to use an ad-specialties company.

Sometimes you might have the need to use some promotional items with a campaign or conference materials. People always like to get something; this gives you another place to put the important message.

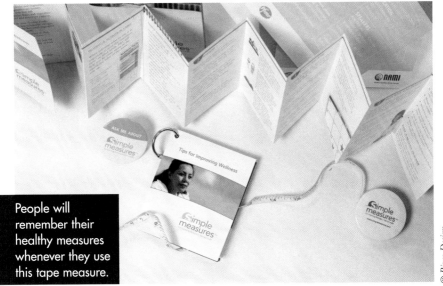

People will remember their healthy measures whenever they use this tape measure.

© Rizco Design

The Least You Need to Know

- Ad-specialty companies can provide catalogs with a wide variety of promotional product options to get your creative juices flowing.

- If you only need a small quantity of promotional products, producing them yourself is probably a smarter approach; ad-specialty companies can produce almost anything for you, but typically in a minimum quantity of 250.

- You can fairly easily transfer a design onto a variety of media, including paper, fabric, glass, or ceramics, for example, using transfer papers.

- Paper promotions are fairly quick and easy to design and produce, either in-house or with the assistance of a local copy shop. They are also generally well received, because everyone has an ongoing need for notepads, and sticky notes, among other things.

- When designing for a promotional product, you'll typically only want to include one logo, tagline, or brand image, to make sure it is easily recognizable and legible.

- Must-have website components

- Balancing style with functionality

- Ensuring you use web-safe colors

- Animation do's and don'ts

CHAPTER 23

Websites

Websites are the new essential marketing tool. Ever since consumers and business professionals made the Internet their first stop for information and research, online has become the new marketing frontier. If you want your target audience to find you, you need a website.

However, designing for the Internet is unlike any other design environment. You need to take into account the approximate screen size viewers will be looking at, and yet the site can consist of as many pages as desired without an exponential increase in cost. Colors will be slightly different from those seen on paper, but they are no less vibrant. Legibility remains an issue, but there are only a handful of typefaces you'll want to choose from.

Audience

Although the world is your audience when you're designing a website, you really only need be concerned with your target customers—the people you want to attract to the website. Instead of trying to appeal to anyone who might stumble onto the site you're creating, design it to entice those valued prospects and customers to buy.

Interestingly, only a few years ago, the common wisdom was to design assuming that everyone only had dial-up access, meaning that it took quite a while for the site to load if you used a lot of graphics. The rule was to design for "the lowest common denominator," meaning those with slow computers. As a result, designers scaled back the images and took great pains to help the sites *load* quickly.

Today, however, designers assume that the majority of web visitors have broadband access, not dial-up. They also design for PCs, Macs, and Unix operating systems to ensure that virtually everyone will be able to access the site.

Visual Elements

There are standard pages and components that nearly all web-savvy visitors will look for. Excluding any one of these components will make a website appear amateurish, and may frustrate visitors who might be looking for a particular piece of information. Unlike many design projects, there are several features all websites should have, including these:

- Navigation buttons
- "Contact Us" button and page
- "About Us" button and page
- Privacy Policy link at bottom of home page
- High resolution image(s) on home page
- Home-page button in upper left or right of the page, to get back there with one click

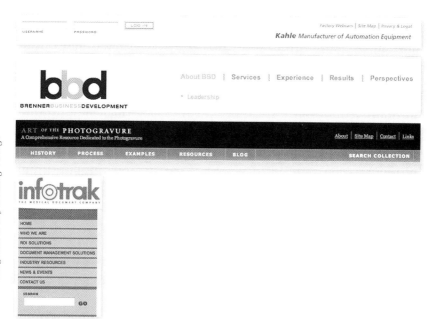

© stressdesign and © Toky Branding + Design

The clickable words/icons enable you to move to other parts of a website, and are called navigation buttons. Here are four different designs from websites.

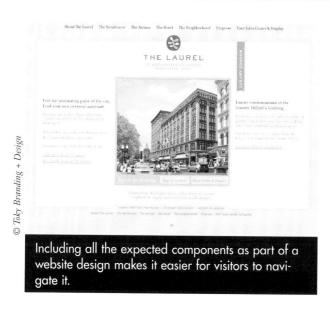

© Toky Branding + Design

Including all the expected components as part of a website design makes it easier for visitors to navigate it.

Of the separate pages on a website, the home page—the first page a visitor sees—is absolutely the most important. Every home page should have, at a minimum, the following:

- Navigation buttons, generally on the page left
- A corporate logo and name featured prominently
- At least one image, such as of a product or key executive
- Some indication of what the organization does, such as a mission statement

Try to keep your home page simple, to draw visitors in, rather than overwhelming them at first glance.

Typography

While there are thousands of possible typefaces, many of them quite fashionable and cool, when you're designing for the web, you really only have four typefaces to choose from that are guaranteed to be in all computers:

- Arial
- Georgia
- Times Roman
- Verdana

Sure, you can use any typeface, but the less mainstream it is, the less likely your viewers will be able to see your site as you designed it. Their computer will substitute a default typeface that may look nothing like what you had planned. For that reason, it is smart to stick with the four web standards.

This is the Arial typeface.

This is the face of Georgia.

Times Roman is an old tried and true.

Verdana's look is clean and clear.

These are the universal typefaces found on all computers—the easiest to read onscreen.

However, if you are dead set on using a more decorative or script typeface, for example, your other option is to convert the type to a graphic element, rather than text. The casual user won't be able to visually tell the difference, and doing so will keep the typeface exactly as you want it when it loads on visitors' computer screens. The downside is that you won't be able to easily edit the words within the graphic because it will be formatted as one picture.

Reverse Type

If your site consists almost entirely of graphics, rather than text and graphics, search engines will not be able to scan and process the words on your site; this may mean that your site will not appear near the top of search engine rankings. Without text, search engines have no way of gauging how relevant your site is to searches visitors make. That's a *big* problem. And the result is that your website will be listed much farther down in the results search engines like Google provide.

If you expect to update the website on a regular basis, it will be much easier to accomplish if you keep text as text and not a graphic element. Otherwise, you'll need to create an entirely new graphic every time you have to change a word.

Color

The colors you choose to use are just as important in a website design as in a brochure or logo, and the process you use to select them should be the same. What is different, however, is how color is perceived onscreen versus in print.

Whereas color printed on paper consists of ink or toner, color presented on a computer screen consists of *bits* and *bytes*. It is defined as different from ink colors simply because of how it is formulated—shades are created from mathematical calculations rather than tonal combinations.

To ensure that the colors you select appear properly onscreen, you have to specify your color scheme as "web-safe." You do this when you open the color selector, or color picker in Adobe Photoshop, where you choose from five options:

- Hue (a perceived color in terms of lightness or chroma—its colorfulness)/saturation (the intensity of a specific color)
- RGB (red, green, and blue—additive color)
- CMYK (cyan, magenta, yellow, and black—process color)
- Lab/color
- Number—indicating web safe, usually shown as a numerical and/or letter combination

That numerical combination is the computer's calculation of a web-safe version of your color choice. The number 993399 is actually the value for the web-safe equivalent of the Pantone 513C, seen in the previous figure; other colors will be represented by different combinations.

Always use a web-safe color palette and resist the urge to use spot or process colors. You might like the larger variety available in the Pantone color set, but all computer screens will see it differently

than yours. Using other than web-safe palettes is a sure sign of an amateur.

You might want to consider the psychological effect color plays on the viewer as well. Red invokes feelings of love, passion, danger, excitement, and action. Blue brings feelings of trustworthiness, success, seriousness, and calmness. Green reminds us of money, nature, health, and life. Orange gives a sense of comfort, creativity, fun, and youth. Purple is associated with royalty, justice, ambiguity, uncertainty, and dreams. White represents innocence, purity, cleanliness, and simplicity. Yellow brings feelings of curiosity, playfulness, and cheerfulness, while pink makes us think of softness, sweetness, innocence, and tenderness. Brown represents the earth, nature, tribal, and primitive, and grey represents neutrality, indifference, and a reserved demeanor. Black represents seriousness, darkness, mystery, and secrecy.

Remember readability and vibrancy with color, too. Don't select color combinations that are jarring to the viewer, refer to your color wheel to select complementary colors.

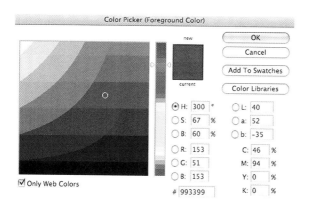

This image shows how PMS 513 is represented for the different systems.

Creative Speak

To improve onscreen legibility, make sure the copy featured in the website you've designed is sufficiently contrasted from the background color. In general, black copy on a light colored background is the most easy-to-read. Colored copy, unless is it dark grey, navy, or dark green, will also be hard to distinguish.

Design on the Cheap

If designing a website from scratch is not possible due to time or budget constraints, another option is to go with turnkey website providers. You choose from among a set of templates, lay in your copy and graphics, and you're done. The cost is minimal, but so is the possibility to make many modifications.

Animation

When animation was first developed for the web a few years ago, every web designer used it. At the time it was the cool, new technology that everyone wanted to play with and incorporate into new websites. That was then; this is now. And now, the best websites make judicious use of animation software such as Flash and After Affects.

There are certainly times when animation can really jazz up a site, including the following, for example:

- To show a process in motion
- To incorporate a game
- To showcase several products simultaneously
- To draw attention to a particular graphic element

While there are certainly many more possible uses of animation, these are the major uses you'll want to consider.

Having said that, should you decide that some animation will significantly improve the impact of the website you're designing, you'll want to hire an animation guru to assist you. There is a huge learning curve to becoming adept at using the various software programs available for animation—so much so that you'll want to outsource if you need to get the site done anytime soon.

© Imagery Media

This jump sequence shows how each frame of an animation looks in static motion.

The Least You Need to Know

- There are several components users expect to find on every website: navigation buttons, a Contact Us page or link, an About Us page, a quick link back to the Home page on subsequent pages, a privacy policy, at least one high-resolution image on the home page.

- Despite the myriad typeface options available, only four are guaranteed to be visible by all computer users: Arial, Georgia, Times New Roman, and Verdana. These typefaces come loaded on all new computers, while others are not necessarily available.

- Color looks different onscreen versus on paper, so you need to make sure you specify "web-safe" colors in your design, or else the shade you see may not be what you expected or wanted.

- Assume the majority of site viewers have a broadband connection, but don't overload your design with so many images or animation that it takes more than a couple of seconds to load. Slow sites are often abandoned by visitors before they are fully visible.

- Adding animation will not necessarily make your site look any better, or make it any more effective at drumming up sales. Animation used today is generally much more subtle and complex, and requires the services of animation gurus to do it well.

GLOSSARY

alignment The positioning of all elements on a page. Typical alignment is flush left, but can also be flush right, centered, or justified.

all caps Short for type that is presented using all capital letters.

art director The person responsible for managing creative and production staff on a given project.

ascenders Letters that rise above the x-height or the top of a lower-case letter.

assemblage Collages are those combinations of images on a flat surface, whereas assemblages are variations of collages using found objects—anything discovered, perhaps on the street, outside, you name it—creating a 3-D image.

author alterations A design term referring to changes (not corrections) that a client requests. Often these changes go beyond the original client scope of work and add additional expense to a project.

banner Graphic images created as advertisement for web use. Can be vertical or horizontal placement. Sized in pixels.

bleeds The runoff on a page that occurs as a result of how color or an image is printed. There are no margins of nonprinted space before the edge of the page.

blog Blogs, short for web logs, are electronic personal journals in which individuals can post their opinions, recommendations, or observations 24 hours a day, 7 days a week. Anyone online can find and read them.

brand A brand is the overall image of a company or product, whereas the logo is a single image or mark created to identify the company. The yellow and red Eastman Kodak Co. "K" is not the company's brand or image, but its logo.

coated paper Paper that has a coating (usually clay-based) applied to make it smooth and glossy; uncoated paper lacks any kind of sheen.

collaterals In design lingo, printed documents used to promote a business. Different from advertising, these are used to build a brand, support the overall mission or message of a company, and provide ongoing public relations.

comprehensive A design term that means a mock-up or dummy, sometimes referred to as a "comp" to designers. Comps show use of color, the size of the finished piece, and paper used for a project.

CMYK A subtractive color model used in digital output that is based on the four colors used in process printing: cyan, magenta, yellow, and black.

crop The method of trimming an image to fit a need. Also a tool used to trim away the edges or part of an image.

density The opacity an object has. This term can also be applied to typography to reflect the ink coverage a letterform has on a page. Bold type is denser than regular or light versions.

descenders Letters that drop down below the baseline or bottom of most lowercase letters. The letter "t" has an ascender, and the letter "g" has a descender, for example.

dimensional mail Dimensional mail refers to packages of an unusual shape—also called lumpy mail. Rather than flat envelopes, some direct-mail companies now enclose an item with weight, such as a pen or golf tee, that ties into the theme of the message.

DPI (dots per inch) This is the number of dots, or pixels, that fit horizontally and vertically into an inch. The more dots (or pixels), the more detail is captured and the sharper an image.

dummy Also known as a mock-up, a paper replica of your finished piece, minus any of the design.

emboss An effect done mechanically in printing and finishing, as well as a technique that can be used in some software, to give a raised depth to a piece. A blind-emboss is the given texture without ink; debossing gives negative, or a depressed, impression.

export A technique used to prepare files for output to software, printers, or computer platforms.

e-zine (electronic magazine) Also known as an e-newsletter, it's short for electronic newsletter. It's simply an online version of the printed newsletters we're used to seeing in our mailbox.

font The computer programming used to describe a complete set of characters in a particular typeface collection. Typefaces consist of characters, letters, and other special features as part of a font set.

four-color printing The equivalent of printing in full color, to get photographic quality. Less than four-color printing means that you will specify each color. The most common ink color in one-color printing is black. In two-color, the designer usually chooses another color, such as red or blue, and black.

GIF Graphics Interchange Format. A common file format for use on the web because of the small file compression size. This format is unsuitable for professional printing, but is great for the web.

GNU A computer operating system created using open source-code software. Open source code is available to any developer to use copyright-free as long as the developer fully follows the usage rights as defined in the Open Source Definition (OSD).

graphic design Defines the visual representation of an idea or concept. This relates to all activities involved in visual design, including brand identity, logo design, environmental design, and web design.

graphical user interface Utilizing pictures to help make computers more user-friendly, including icons, windows, and menus. It is most evident in the appearance of the computer desktop.

greeking The use of nonsensical text in a sample layout, such as starting with the words "Lorem ipsem dolor sit amet." The words mean nothing, but help graphic designers envision what the completed copy will look like on the page.

high-resolution image An image with a high level of sharpness and clarity. A low-resolution image is one used for proofing, not suitable for professional printing.

hue A color's shade, or where it falls on the spectrum of lightest to darkest within its color family. For example, lavender is a lighter shade or hue of purple, whereas eggplant is a much darker hue, although both are still purple.

information graphics A special area of graphic design that reflects clear, visual representation of complex data. It consists of important information that needs to be quickly or simply explained. Subway maps and charts and graphs fall into this category of design.

information kit A folder containing an important announcement, and plenty of background information about your company, called backgrounders. Photos of key executives, products, facilities, or events are another possible component.

JPEG The most common digital file format for images; stands for Joint Photographic Experts Group—the group that created the file format. Macs and PCs can generally process JPEG files, although TIFF (Tagged Image File Format) and GIF (Graphics Interchange Format) files are also fairly common formats.

kerning The horizontal spacing between letters. You can adjust the kerning to make the letters closer together or farther apart. This is not the same as tracking—which refers to adjusting the overall spacing of a group of letters.

leading Measured in points, it defines the space between lines of text. Pronounced "ledding," it is the vertical spacing between lines. You can also adjust the space above and below a line to tighten text or to add more white space on the page.

ligatures Combinations of two or more glyphs or characters presented together as a single form. They include combinations such as fi, fl, ffi, ffl, th, and sometimes st, ck, and cky. These combinations are unusual in that, when presented alone, the spacing between is out of proportion and the characters look too far apart. When treated as ligatures, the space between them is made proportional.

load time The time it takes for a website to be completely visible onscreen is the time it takes to load. The more graphics on the page, the longer it will take to load, because the computer has more information to process.

margins Guidelines in layout software showing where copy and images can be formatted. In design-speak, it is the space around text. Margins and guidelines do not print.

market segmentation The dividing of one group of customers into ever-narrower groups, based on factors such as income, spending habits, age, age of children, proximity of home to store, education level, and other factors.

Pantone Matching System Referred to as PMS color, this matching system is used to specify color as it applies to use of ink for printing. There are PMS guides for use in printing, onscreen, and digital printing, and they vary according to system used.

PDF Short for Portable Document Format, it is a means of saving files and sharing them electronically. PDF files look like a printed document, but are printed by the recipient with their own equipment.

pixel The smallest picture element, often referred to as a dot or square because of its size.

portfolio All creative types, such as graphic designers, collect samples of work they have completed for other clients, and present them in a binder or case, called a portfolio. A portfolio should show a designer's best work.

portrait orientation Pages oriented so that the shorter width is at the top, such as with an 8.5×11-inch sheet of paper. When the shorter width is on its side, so that the 11-inch side is at the bottom and the 8.5-inch side is on the side, it is called landscape orientation.

primary colors Basic colors used to create a full color-range model (nonprimary). The additive color model is red, green, and blue; the primary colors for the subtractive color model are cyan, magenta, and yellow.

raster-based images Also known as bitmap images, these images represent a collection of pixels organized on a rectangular grid. This file format is intended for displaying photographic images.

reach In advertising lingo, it is the number of people who are exposed to your ad. The more people who read a magazine, the higher the reach; as with pass-along readership, the numbers can go higher. The more people who see it, the lower your cost per impression (CPI).

resolution The density and clarity of the image itself. The better the resolution, the crisper, clearer, and more vibrant the photo appears.

RGB An additive color model in which all colors are derived from adding Red, Green and Blue light together. White is a combination of pure Red, Green and Blue lights. Black is the absence of all three. Used to define colors on monitors and televisions.

screening Reducing the intensity of the ink in an image, from 100 percent down to 60 or 50 percent, or less. So instead of black, for example, you'd see charcoal or light gray.

shareware Software applications made available online by the developer to try for free. However, most developers ask that If you decide you like the software, including templates, you pay a nominal fee for continued use. You're on the honor system, and fees are usually reasonable.

stock images Also known as stock photography, photographs taken by photographers that can be licensed for use in your designs. You pay a usage fee, often based on how large it will be in final form and how many people will potentially see it. You are granted permission for one-time use.

swash More ornate versions of letters. Parts of the letters are usually extended, adding extra embellishment to a letter's form.

symmetrical Equally balanced elements that reflect each other, while *asymmetrical* elements are not balanced.

thumbnail A smaller version of a design sketch. Usually referred to in a preliminary, concept-development phase.

TIFF (Tagged Image File Format) A common file format used for saving bitmapped images such as scans and illustrations.

Tracking Adjusting the spacing between letters in a block of text, as opposed to individual letters (kerning). Also known as letter spacing.

visual hierarchy In design, the order of importance that information is arranged. This includes positioning on the page, size, scale, and weight (or density) of an object on the page. This can refer to typography, image, or overall design.

vector-based graphics Images created mathematically, resulting in a crisp, clean line and edge, which is important when drawing shapes such as boxes or triangles. Vector graphics use points, lines, curves, and polygons to create shapes using mathematical equations.

void Space, often referred to by designers as *void or negative space*, it is among one of the designer's best tools. Also referred to as "white space."

wafer seal A small circle, although it can really be any shape, with adhesive on one side. It is placed on the edge of a fold, holding the two pieces of paper together during mailing.

INDEX